Journeys toward an Art Autobiography

Peggy Polson's Peregrinations

Peggy Polson

ISBN 978-1-7335602-3-8

Design by Niki Harris Graphic Design
Eugene, Oregon

Covers: details from *Exuberant Cannas (see page 153)*

To my parents, who welcomed me back whenever I needed "home."

Peggy Polson in 2018

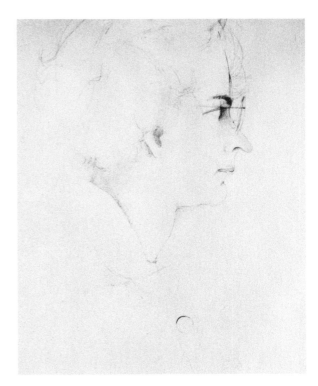

Detail of pencil self-portrait
(photographed in 1964; drawing was formerly
in the Self-Portrait Collection at Appalachian
State Universtiy, Boone, North Carolina)

Acknowledgments

I am most grateful to Claudine Harris and her daughter,
Niki, who worked together, starting in 2007, on Claudine's
memoirs and a striking series of small books of photography
and poetry. They inspired me to develop my own art memoir.
The privilege of working with Niki, a graphic designer, editor
and artist in her own right, has been one of delightful joy.

Dear friend Andrea Rauer, who succeeded me in my garden
apartment, verified many details, and supported the later stage of
book production, thankless tasks for which I sincerely thank her.

The scholarship of John W. Dixon Jr. in art and religion
has influenced me along with a lifelong fascination with
artist Paul Klee. My teacher and mentor, Virginia A. Myers,
helped me recognize "my voice" in the various years of
study with her in printmaking and foil imaging.

Contents

Organization of this book

The first part of the book (pp. 14-81) is the narrative. Thumbnail sizes of Peggy's artworks, may be connected to the text or included for decoration. Each one is labeled with a page number referring to its enlargement in the second part of the book (pp. 83-157). That section presents the works in approximate date order. A page reference in the caption will occur only if the work is discussed.

We went out to draw, friend,
But admired the lines in the trees instead.
We went out to draw, friend,
But stopped and talked with friends.
We went out to draw, friend,
And saw a new land before us.
Now friend, draw — while your
soul is full of hue.

Poem scribbled on a scrap of paper

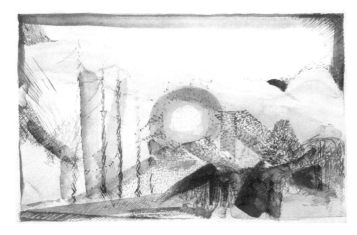

Landscape Mandala, 1986, watercolor, 22 x 30

Introduction

Nurtured as a child in gardening, I developed a love of flowers and the floral forms that has accompanied me throughout my life. More than sixty years of artwork, playing with floral and plant imagery and more recently, vine entaglements, resonate with my love for the natural world. Most times, the images celebrate the qualities of the medium through which they are made. Other times, the works offer subtle indications of a greater universe existing beyond our culture. A few may even point beyond themselves to the realm of the spirit.

As I am working on a composition, I sometimes feel a pull beyond myself that orients the work in a new direction. Starting with an object, a new layer appears, more abstract in its quality, which encourages the piece beyond my original conception. As competing parts settle, a new rhythm emerges, the work becomes a harmonious whole. Such art is the event when relationships come together into a unique aesthetic that points beyond itself. "That's beautiful!" we exclaim. "Just right!"

On rightness, John F. Haught, *The New Cosmic Story*, p. 55, wrote,

> It's not hard to notice that your own mind is already attracted, at least tacitly, to what I am calling rightness. To be specific, you are looking for right understanding,

page 144

page 110

14

another name for which is truth. Perhaps until now you never noticed your natural attraction to rightness. This is because rightness is not intrusive. Rightness beckons you gently and humbly. It does not force itself on you. Your mind comes in touch with it only by anticipation, not by possession.

page 109

Recently, I was startled when I discovered old sketch books that contained writings and images of concern that still involve me today. I hadn't realized that growing up took so many years!

Looking back over my life I realize the importance of journeys, especially my travel adventures to other countries. Introspections have emerged from these that I have returned to in my mature years.

I am privileged at this stage of life to recognize an ever-deepening imaginative strength as I learn to see better. I have experienced ever-deeper imaginative states while developing my artwork and writing this art autobiography.

Peggy Polson, Summer 2019

Daughters

"I do not want an April Fool's baby," my mother declared to
the doctor at the Roanoke Hospital. Her first baby had been
stalling around for hours after the hurried, 30-mile ride over
bumpy roads from Blacksburg, Virginia, amidst a threatening
snowstorm. Later that afternoon, the baby girl was born. ("Are
you fit to be the mother of a Virginian?" Mother smiled as
she read the pamphlet from the state.) They flicked my feet
to get me to suck nourishment; I simply wanted to sleep. The
decision was made to name me "Margaret" after my father's
mother and "Ruth" after my mother as a middle name. All
was accomplished on March 31, 1931, hours before April 1st
dawned. "Peggy" became the nickname at age three days to
distinguish me from "Mother Margaret," Dad's mother.

After my birth my father struggled to finish up his dissertation
for the University of Wisconsin while teaching at Virginia
Technological Institute. He found a job in Kentucky, but
within 24 hours an offer came from Cornell University. My
father wired Lexington, "Disregard letter. Have accepted a
position at Cornell University." Within the year we moved to
Ithaca, New York.

In preparation for another baby's birth, a bassinet was fashioned out of a wicker clothes basket and placed in my parents' bedroom. I would tiptoe in, lift the cheesecloth drape and announce, "no baby yet." I was just three years old.

Whereas I entered the world slowly, Marion arrived quickly, bawling at the top of her lungs. The doctor had called across to my mother, "Hold on, girlie, until I get my hands washed!" February 28, 1934, was the day of her birth. When Marion was brought home from Tompkins County Hospital, 10 days later, I was in the back seat of the car wearing a new plaid jumper for the occasion. Stretching up to my full three-year-old height I tried peering over the thick, fur collar of my mother's heavy coat, trying to see Marion. I remember my utter frustration over not being allowed to see her in the car. Bundled in pink blankets, Marion was held close by Mother. The nurse had instructed my parents against exposing my sister to the wintry air. When I first beheld Marion, I don't recall. This was the start of my training in patience, accompanied by a desire to see better.

Marion was named after a Scottish aunt who spelled her name ending with -on, the masculine spelling in the United States. This didn't cause difficulty except once on a tour where her roommate was discreetly changed to a woman.

Though very different in personality, we grew up amiably within the same household. She embodied an extroverted personality while I possessed an introverted nature. We usually worked out our squabbles; however, during one heated encounter, I slammed the closet door on her retreating left hand, catching her little finger in the latch of the door. Marion's screams brought Mother running upstairs. I stood stricken as the blood flowed. Mother phoned Dr. Lee, our family physician, who said to bring her in.

At his office, Dr. Lee carefully reshaped the smashed little finger. Week after week of patient reshaping of that torn flesh, the wound healed. Several months later, he triumphantly called out, "She has a nail!" Sure enough, much to the relief of all of us, especially Marion, the small moon of a nail was emerging. A bit off center, it grew to resume its rightful place on her left hand's little finger. I fought back tears of relief; I hadn't maimed her for life!

A letter I wrote to Marion around 1960 while studying for the Masters of Fine Arts at the University of Iowa.

Darling,

You and I have grown up in a family system that puts stock and security in professional degrees. We now live in a society that determines its class system by these qualifications. Unfortunately, the tendency is to note the accomplished qualifications rather than the quality of the person's work. In addition to trying to meet with the family's expectations along these lines, you and I also want to feel secure in the quality of the work that we produce. In fact, we are not certain we even want to produce it (fear of criticism, social disapproval, heaven knows what others lurking within the subconscious).

Professional work assumes that you rate it first in your personal value system. If you don't, you feel out of kilter with others' expectations. And why shouldn't you feel out of sorts while inside your physical desire clamors for fulfillment, obedience to family authority taunts you, and then disturbing thoughts of what you are and what you want to become desire expression.

The visual arts are among the few islands left where the professional is as yet not the determining factor of quality. The criterion is the quality of personal expression. Increasing pressures negate this. In the exhibition circles now, quality of expression is no

longer a criterion. The force of expression, its originality (crude-
ness enhances its quality) are the influencing qualities.

In the abstract expressionist school, the force of the abstraction—
colors, shapes, lines, textures are gross, vehement, frequently crude
statements. But where is man [and woman]? Where is there an
appeal to human sensitivities, feelings, searchings?

[Professor Mauricio] Lasansky feels that printmaking owes its ap-
peal to humanness. The size and the subject matter usually involve
a human dimension, at least with the Iowa Print Group here.

It is this that you and I are crying for, honey—a quality of our
humanness through which we can communicate and contribute to
others. Which quality we aren't certain of yet. We hoped, expected
to find it wrapped in gold tissue at college, in line with the pro-
fessionalism within which we grew up. Now we are realizing this
quality lies in life itself. We find it revealed in ourselves, outside of
the university circle. We are shocked into realization by the new
environment. We can see more clearly our strengths, our weak-
ness, against new values. We are removed from the life that we
take for granted. Its real value emerges when we are away from it.

We owe it to ourselves to test its values, Marion. How are we to
know that it is worth struggling for until we can feel it, need it?
Fly, honey, try your wings. Home is there if we need it.

Meditation on Marion

We lost Marion at age 41 to cancer. She had three years of
treatment at Sloan-Kettering in New York City, enduring
various chemo, radiation, and surgical procedures. Between
hospital stays, Mother took care of Marion in her NYC
apartment. As Dad found it difficult to cook for himself and
became depressed with loneliness, Mother would fly back to
Ithaca to tend to his needs for a while. Later, when my parents
confronted the doctor about Marion's deteriorating condition,
he admitted that she would never become well again. The
decision was made to transfer my sister closer to my parents'
home. With an ambulance's sirens blaring, much to Marion's
delight, she was driven to the airport. From there she was
flown by a medical Lear jet to Ithaca. Transferred to another
ambulance, she was driven to the Tompkins County Hospital,
now located outside of Ithaca. Her hospital room overlooked
rolling green lawns stretching to a thick stand of trees covering
the hillside down to Cayuga Lake. Sometimes she saw browsing
deer, which reminded her of the deer at our family's cottage.
Suffering a staph infection, Marion was blessedly released in
about a month's time on June 6, 1975.

While she lived, I visited her in her New York apartment or the
hospital room during my teaching breaks from Appalachian
State University. The last time I saw her was at the Wagner

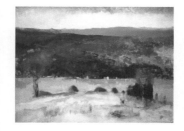

page 92

Funeral Home in Ithaca, lying in her casket, the day before her memorial service and family burial at Eastlawn Cemetery. Her thin, shriveled arms ended in clawed hands drawn up over her wounded abdomen, operated on nine times. (The poignant image of *Dead Canary* came to my mind—the utterly still, feathered body, legs drawn up, feet curled, in death. Painted by Albert Pinkham Ryder, the small painting resides in the Phillips Collection, Washington, DC.)

I drew Marion's portrait from life as she sat in a chair in the family cottage with her arm upraised over her head (see page 93). This was approximately 1972.

One time, in her apartment, she had asked me, "Is there reincarnation, Peggy?" I said softly, hesitating, "There must be."

Trained to be a counselor, Marion was motivated instead to work as an auxiliary policewoman, patrolling a beat in New York City. Police worked in pairs; frequently her companion was a Puerto Rican man who, though shorter in stature than Marion, enjoyed her company because drunks were easier to handle with a woman present. She was cited for bravery after a challenging scuffle. Marion proved her bravery as she struggled with cancer. The suffering seemed to strengthen her courage and deepen her maturity. Yes, Marion, may your soul be radiant within a resonant spiritual body where disease is no more.

page 93

page 106

I have found solace and insight reading the works of poet Mary Oliver. This is the last part of her poem entitled "The Journey":

But little by little,
as you left their voice behind,
the stars began to burn
through the sheets of clouds,
and there was a new voice
which you slowly
recognized as your own,
that kept you company
as you strode deeper and deeper
into the world,
determined to do
the only thing you could do—
determined to save
the only life that you could save.

First published in 1986 in *Dream Work* (Atlantic Monthly Press)

Childhood Meditation

There was a creek that ran along the lower lot below the house where my sister and I grew up in Ithaca. As a child I would sit on a rock beneath a sheltering tree overlooking the gurgling stream. I would daydream, quietly humming to myself. I watched the water slipping along over the limestone surfaces, eddying in small pools, before cascading on down the creek. In dreamlike moments those surroundings seemed suffused with the sense of a greater immensity.

page 105

Mother

Mother excelled as an intellectual and as a musician. She accomplished her master's degree while she taught English and music at the secondary level in the Ithaca public school system. Later she obtained her PhD in American literature and rhetoric during World War II. Her talent as a mezzo-soprano was shared as a soloist and conductor of choral groups in the community. I would fall asleep upstairs as she practiced in the music room downstairs.

page 127

Mother's skills led her to trustee positions with the First Congregational Church and the New York State library system. She organized others to care for the house, look after Marion and me, and help with the meals when we were very young. An excellent cook, Mother prepared the evening meal. Marion and I learned to assist her, and on Sundays Marion and I took turns cooking the noonday meal. Lamb chops, frozen peas, and a baked potato became standard fare. Mother handled the never-ending entertaining obligations of her professional husband with the assistance of her daughters.

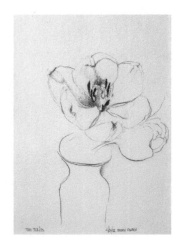

page 142

Father and the Philippine Journey

As a Cornell University professor my father taught courses in rural sociology and worked as an extension agent throughout New York State the first 25 years of his career. The next 25 years focused on foreign students, teaching the graduate courses, and mentoring their advanced degrees.

Dad's research centered on social change in the Philippine Islands. On a Fulbright award, he and Mother, Marion and I embarked on our first foreign venture as a family in 1952 to 1953. We stayed 10 months at Silliman University, living in faculty housing within Dumaguete City on Negros Island. My father would never have risked his family's welfare had he not known about the artesian well being the source of clean water for the area. Dad's mission was to establish a rural sociology department at the university, which had been devastated by the Japanese during World War II.

While Dad conducted his research from a card table set up in our parents' bedroom, Mother taught English and choral speaking classes (a lesser-known art today). My sister finished her senior year of high school. As a junior in college, I took education classes and ended up teaching history of architecture and modern art when the home economics teacher became sick. She suffered the ill effects of malnutrition from when she

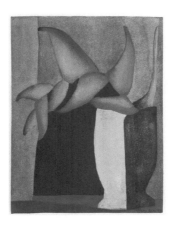

page 85

had been a war prisoner of the Japanese. My first paycheck for teaching was in pesos. I was 22 years of age.

As a painter, I researched and selected a basic set of paints to take with me to the Philippines. Because these casein paints were based on a milk protein, I could use water as the medium and for cleaning up the brushes. Using heavy paper, I painted images of the tropical flowers, such as ginger (see page 85), that grew in pots on the porch. I also painted the gorgeous bougainvillea vine (see page 84) that grew over the entrance arch to our neighbor's house across the street. Though orchids were prolific growing in containers on people's porches, I didn't paint any. (I drew orchids in my later life.) Though already familiar with our Christmas poinsettias, I was unprepared for the over six-foot hedges of huge red blossoms growing there. They filled me with awe.

My bold painting of the caladium leaves (see page 86) was motivated by a plant found among the collection on our porch. Strong shapes, strong colors state the drama of this growing form. Close view of the dark leaves shows incised lines as structure and outline. From the back side, the force of these lines carved the soft paper and the paint bled through. This 1953 painting presages the direction of much of my future work—florals and intaglio printmaking.

page 84

page 86

28

My parents returned to the Philippines two or three more times. My sister and I remained stateside, concentrating on furthering our education and gathering job experience. Marion became interested in counseling and stage managing while at Rollins College, Winter Park, Florida.

Whereas music provided Mother's expressive outlet, gardening restored my father's equilibrium after demanding days at the office or traveling. In Ithaca, Dad developed the multilevel gardens surrounding the new family home, whose construction he carefully supervised during the mid-1930s.

In the limited space between the driveway turnaround and the ornamental bushes, my father helped me to establish a little garden. I became especially fond of the portulaca plants that survived the heat, rain, and neglect, blooming profusely in the gravel along the driveway edge.

After my Philippine plant compositions, I produced more abstractions of flowers during my senior year for my Bachelor of Fine Arts degree at Cornell University. There is the vibrant *Red Tulip Flower* (see page 87) with its subtle orange pistil and ovary pouch guarded by the stamens in white and yellow ocher lines. Red-orange tones define inner petal formations throughout the blossom. Careful hours were spent applying the

page 87

29

purplish feathered lines to the inside of the tulip to establish a vertical on the left side as well as tracing the long curved edge defining the tulip's opposite contour. This was a technique used by Joseph Mellor Hanson, a professor of painting and drawing at Cornell who had studied with the French artist Amédée Ozenfant.

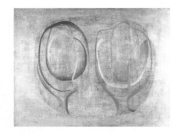

page 88

I explored that technique further in *Green Painting with Two Floral Heads* (see page 88). The egg-shaped oval on the left dominates by its darker hue, while on the right, the shape and colors swell into a budding blossom. The encircling oval defines the yellow-toned background.

I see abstracted floral heads, their nascent flowering, the development of seeds, and their return to the earth. I also see ovals posed on necks, a human couple, the linen canvas's yellowed tones suggesting an old photograph.

A memory

With Dad being a professor at Cornell, my academic studies there were part of his employment benefits. A treasured memory is marching in the graduation exercises with my father, both of us in academic robes, when I was awarded my Master of Science degree in Applied Arts.

Lilac Mandala

A vivid recollection and an intense aesthetic one returns to mind: I had been up all night studying for an exam. As the day dawned, I gulped down a quick breakfast, then dozed for a few minutes on the floor of my Cascadilla dorm room.

I needed to get going. I made my way downstairs and opened the front door. The sunlight dazzled my sleep-deprived eyes. Breathing in the brisk spring air, I walked past the lilac bushes lining the pathway along Cascadilla Creek.

page 137

The buds were unfurling in the morning light, revealing leaflets clustered around the floral heart of tiny, curled buds nestled in the center. I looked deep into the center of the leafy mandala. Surrounded by the glistening dew, the budding took on an ethereal glow; the shimmering loveliness drew me deeply within its aura of scintillating beauty.

I hold no memory of how I did on the exam. There is simply a lingering vision of an enchanted moment, walking to class on the Cornell University campus in spring, that also became a wellspring for my own artwork.

page 137

First Iowa Experience

After my BFA I shifted to an Applied Art degree from Cornell's College of Home Economics, and from there, Iowa State University hired me to teach Design, for home economics students. After two years of work there, I resigned and started studies toward a Master of Fine Arts at the University of Iowa in Iowa City. Lester Longman, the director of the School of Art and Art History, believed strongly in an institution where studio art and art history were taught alongside each other. This emphasis appealed to me.

The first assignment in the Print Studio was to do a self-portrait (see page 90). I labored over drawings to come up with one I could etch into a copper plate. Finally, I selected one drawn when I was wearing a bulky blue sweater with a rolled collar. As I kept developing its lines on the plate, they became constricted; the collar didn't roll in an attractive manner. Lasansky came by with several long strips of flexible cardboard and a dab of ink on another piece. "Let us free up these lines," he said, as he flipped ink onto the copper plate over the collar. Then with a straight point pen, he pressed down, splaying the pen nib apart, making a long triangular mark in the ink. He handed the pen to me so that I could continue making similar marks.

One of the assistants helped me protect the back of the plate with varnish. When it had dried, we put asphaltum on the front side, covering the surface except where the collar was. When that dried, we slipped the plate into the Dutch mordant acid bath, which etched the new lines into the copper plate. When all the masking material was cleaned off, I printed the plate. The suggestion of a feather boa appeared. I continued developing the tones in this manner until the tight lines of the collar simply became background for the feather boa draped around my neck. The dark tones of a hat and a turtleneck shirt were developed in a similar manner. My expression is serious, even wary. This was my first big print, the plate being 23.5"h x 15"w.

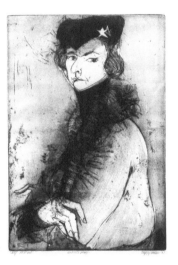

page 90

Parisian Journey

Upon completion of my MFA program, I graduated in June 1961. I visited Paris in the autumn of that year through the spring of 1962. Among the addresses I received from an agency were two places offering room and board.

First I tried the one in Montmartre, the known artists' quarter of Paris. My sleeping quarters were in a long, narrow hallway; I had a single bed with a sagging mattress, tucked between dish cabinets. There was a tall window at the far end that opened onto a small balcony, overlooking the street four stories below. Craning my neck upwards, I could view the mansard roof above.

The lady of the apartment spent her days in conference with a lawyer and absorbed in business affairs. Her son had left for studies in the United States. It was not a welcoming household. After I decided to leave, she showed me her elegant chinoise bedroom.

I contacted Mme. Joba at the other address. Her apartment was in Bellevue, halfway to Versailles, by electric train. I liked the contemporary apartment building where she and her 10-year-old son Paul lived. I was accepted as a paying guest, which included my breakfast and evening meal. I was given Paul's

bedroom; he moved into hers, and she slept on the daybed in the living room. During the day, Mme. Joba translated Nancy Drew stories from English into French.

Every day, I would fix my breakfast. Leaving the apartment, I would walk up the hill to the train station for the 15-minute ride into Paris for my French lesson at L'Alliance Française. Afterward, I would drink an espresso coffee and visit an art museum, concentrating on the featured exhibits. For the noonday meal, I'd eat a modest lunch for Fr.5 ($1.00) at a *libre service* restaurant, then return to paint in my room until supper.

I ate dinner with Mme. Joba and Paul, struggling in French to communicate my thoughts. Paul's animated discussions with his mother helped me.

During this period, I attended a retrospective exhibit of the artist Jean Pougny (1892–1956), earlier known as Ivan Puni. Though born in Russian Finland he was educated at the Académie Julien in Paris. Returning to St. Petersburg, he exhibited with Kazimir Malevich and Vladimir Tatlin, all three abstractionists. With Malevich he co-authored the *Suprematist Manifesto* and exhibited his abstract creations for the new machine age.

At his retrospective, which I saw in the spring of 1962, I was attracted to his experimental works in the mode of

Impressionism. These were painted against a bright red ground. Many Impressionist artists used white or light-colored grounds.

Curious as to whether I could achieve a painting working against such a strong color, I painted a large old house that I passed every day at the top of the hill near the train station. I laid down the vermilion background, let it dry, then painted over it with blues, greens, light reds, mustard tones, and muted, even muddy colors. The vermilion peeks through the whole painting except through the densest trees and the blue sky. A lady gardener attends her plants in the foreground; up-reaching blue trees line the front of the house (see page 89).

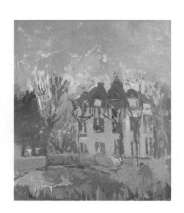

page 89

Later I read Wassily Kandinsky's *Concerning the Spiritual in Art*, where he discusses the different qualities of colors. He wrote the following, which I feel applies to my 1962 painting.

> Vermilion is a red with a feeling of sharpness, like flowing steel which can be cooled by water. Vermilion is quenched by blue, for it can bear no mixture with a cold color: more accurately speaking, such a mixture produces what is called a muddy color, scorned by the painters of today. But mud as a material object has its own internal appeal, and therefore to avoid it in painting is as unjust and narrow as was yesterday's cry for pure color.

Though the colors of blues and greens are the ones that I
am most comfortable with, their use against a vermilion
background creates an image of an ancient house strangely
impermanent in its fiery rose-hued existence in this painting. It
embodies my memory; the actual house was a sturdy gray stone
structure. As a painting, coloristically it is dreamlike and unreal.

Looking back upon this painting, I found myself resonating
with this poem by the French poet Jean Laroche:

A house that stands in my heart
My cathedral of silence
Every morning recaptured in dream
Every evening abandoned
A house covered with dawn
Open to the winds of my youth.

Une maison dressée au coeur
Ma cathédrale de silence
Chaque matin reprise en rêve
Et chaque soir abandonnée
Une maison couverte d'aube
Ouverte au vent de ma jeunesse.

North Carolina

I spent a few years teaching design in Plattsburgh, New York. I still hadn't found my real calling. After leaving my job in 1966, I was drawing and painting in Ithaca. During this time I attended a conference of the College Art Association in Cleveland, Ohio. I heard an absorbing lecture on art and religion given by John W. Dixon Jr. of the University of North Carolina at Chapel Hill. The professor happened to be treating himself to an ice cream soda at the back of the lecture hall. The stool next to him was empty. I slid up on it, introduced myself, and said how impressed I was with his talk and that I would like to study with him. He encouraged me to apply to UNC Chapel Hill. Later I discovered that he held a faculty position in both the art history and the religion departments.

It took a while for me to fit in at Chapel Hill. Women art historians there were dubious of me because I straddled the fence between the making of art and the study of art history. Dr. Dixon recognized the visual strength of my artwork that he had seen in an exhibit at a Chapel Hill art gallery. As I strove toward my PhD in art history, Dixon said, "You have a strong visual memory. Let's capitalize on that. Keep pursuing your interest in Paul Klee."

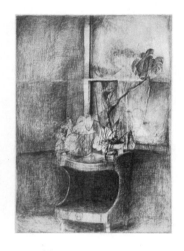

page 91

38

My life seemed destined for greater knowledge about the
Swiss-German artist Paul Klee. As I grew up, I realized that I
approached life's situations indirectly. I immersed myself in
the details of a situation before the overall structure became
clear. Later, I discovered that Klee worked in a similar way.
No wonder I felt intuitively drawn to his work, marveling at
his extraordinary range of form-making. At first, there was
strong fidelity to the natural image. As he developed, his inner
vision grew more dominant. Klee had begun with the usual
materials such as pencil, pen and ink, etching, and watercolor,
but eventually unusual materials would attract him. He
explored glass painting, then later, he investigated color paste
(*Kleisterfarbe*) in his varied, expressive works. Early on, the
Bauhaus group hired him as a teacher.

page 146

page 147

A position opened at Appalachian State University in Boone,
NC; they were looking for someone who could teach both art
history and studio. Professor Dixon recommended me. I drove
across the state and up the mountain for the interview. Two
months later, I had the signed contract in hand, starting fall
semester, 1971, at ASU.

My dissertation, "Paul Klee: A Study in Visual Language," was
not yet finished when I was hired. Therefore, the summers of
1972, 1973, and 1974 were spent in concentrated rewritings.
That last summer, I rented a basement apartment two blocks
away from the home of Dr. Dixon and his family in Chapel

page 94

Hill. Closely supervised by Butterscotch, the yellow Labrador retriever owned by the upstairs neighbors, and listening to Beethoven concertos, I wrote and rewrote my dissertation. Each major rewrite had me knocking at my professor's door at the appointed hour; there were nine revisions in all. A wonderful typist, Frances, put my rewrites into the acceptable dissertation format. In December 1974, the PhD was awarded. As the intense teaching and exhibit schedules moved along, promotions and tenure followed. Summers were spent traveling, studying art, and exploring art museums in the United States, France, and China.

☞

"The artist of today is more than an improved camera; he is more complex, richer, and wider. He is a creature on the earth and a creature within the whole, this is to say, a creature on a star among the stars."

Paul Klee, *The Thinking Eye*

Meditation on Boone, NC

At 3,333 feet above sea level and located in a bowl formation between the Appalachian Mountains and the Blue Ridge range, Boone, NC, experienced changes of the four seasons. Plant types reminded me of ones I had encountered growing up in the rolling hillsides of New York State. In contrast, the Boone area featured dramatic mountain vistas. Driving along the Blue Ridge Parkway on a foggy day felt like entering into an oriental painting as the mist enfolded the car. Also placed 40 miles east of Damascus, Virginia, with four rivers issuing from the base of Grandfather Mountain, each oriented in a different cardinal direction, Boone was humorously referred to as a second garden of Eden.

Before my international journeys of the 1980s and my teaching position reasonably secure at ASU, I started looking at building lots within a mile radius of the university campus. I bought one in a new development on a hillside. Locating an architect, I started planning my studio home. The builder broke ground September 3, 1976. When my parents visited after the house was roughed in, Dad urged me to purchase the lot adjacent to mine, which I did.

With the assistance of a landscape architect, a landscape was planned and beautifully drawn on thick rolled paper. This

featured low stone retaining walls, a variety of trees, shrubs and flowers, including a windbreak of fast growing white pines protecting the house from the prevailing northwest winds. A gardening service was hired to collect and install the plants, as well as care for the grounds. Within the next several years, the house took on a cared-for, settled appearance. I began giving dinner parties. The flowers on my dining table came from my own garden. Weekends were spent in the studio painting or in my study grading papers.

My 1989 intaglio print *Landscape with Moonlight* (see page 100) reminds me of a prominent land feature, Howard's Knob, viewable from the art building in Boone.

page 100

Chinese Journey

In preparation for developing a survey course in Asian art at Appalachian State University, I signed up for a trip to China, "Following the Silk Road," with a San Francisco cultural delegation. The trip was headed by a Shanghai banker's son, a PhD in art history from Princeton University. My mother had heard him present a lecture at Cornell University's art museum where he was distributing brochures featuring the upcoming Silk Road journey. She sent me a copy. Ever since leafing through an art book about the Dunhuang Caves in China, I had longed to see them. These Buddhist caves were a scheduled stop on this tour.

In the summer of 1984, I joined that group from San Francisco following the Silk Road across the Gobi Desert. We traveled not by camel caravan but in an air-conditioned Toyota bus. Early on, we stopped by Dunhuang. The Danghe River wound its way through an oasis of trees, originally a place of refreshment and a water source for caravans starting out and returning from their travels across the desert.

That river, through the millennia, had cut a huge cliff through the sedimentary rock. Buddhist monks had hollowed out caves, some with a pillar of rock left in the center to allow the monk space to circumambulate. A seated Buddha and Ananda

(one of his disciples) occupied a niche on each side. The walls were covered with Buddhist legends and repeated images of the Buddha. Artists from countries around the world were employed to paint and sculpt these images as offerings by the travelers.

In the morning of the day we stopped there, we saw about eight caves. We used flashlights, as there was no illumination in the caves. Because of the number of us interested in art, our leader spoke with the administration, gaining permission to view additional caves in the afternoon. We saw more sculptures during this opportunity. A three-story Buddha was among them. A short, steep climb brought us level with his face. His large, staring eyes looked out right at you and through you.

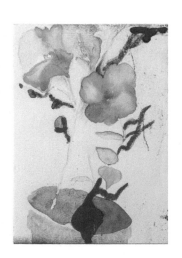

page 95

This first trip to China fueled my curiosity to know more about Chinese art. When a leaflet appeared in my faculty mailbox at Appalachian State announcing a six-week study of Chinese art at the Zhejiang Academy of Fine Arts in Hangzhou, I signed up. Our Chinese leader was a librarian at the University of Minnesota, Duluth. An accomplished watercolorist, he painted early every morning before going to work.

The six weeks proved memorable. Lodged in the "foreign student housing," my roommate was a woman from Sacramento, California, who was also fascinated with Chinese

art. The rest of the group ranged from young teachers to an elderly lady from Boston who already excelled in Chinese painting.

The schedule ran something like this: 6:00 a.m. Tai Chi; 8:00 a.m. breakfast in our dining room; 9:00 a.m. calligraphy lessons until noon; lunch in the dining room; rest in our rooms; landscape painting in the afternoon.

A field trip to the neighboring town of Shaoxing prompted us to use watercolor paints to capture scenes of local interest. My classmate and I missed the return bus to the academy. Realizing this, we hailed a rickshaw driver for the return trip. We showed him the address in Chinese for the art school. He consulted with another driver en route, and in due time we arrived back at the Zhejiang. Two worried teachers greeted us at the gate and talked the poor driver down to a lower fare.

page 96

Another of our field trips featured a boat trip along the Li River. We slipped through landscape vistas, one after another. These looked like classical paintings with distinctive rounded hilltops with single or groups of trees clinging to the high slopes. Throughout the Li Valley the underlying layers of limestone had dissolved in rainwater, leaving the more permanent rock minerals in place. These tall rounded hills receding into a misty distance were a favorite theme for landscape painters from

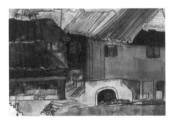

page 97

page 98

the north, especially during times of political turmoil. They traveled south to the Li River area, seeking out peaceful vistas to embody in their ink drawings and painted scrolls.

During this period, I copied a classical winter landscape featuring an old tree, its gnarled roots clinging to the earth (see page 98). I scattered milk droplets, as a resist, onto my work before painting in the sky tones; this suggested falling snow. Later my professor told me if I had blown on the milk, I would have created the effect of swirling snow. The great spatial distance between the tree and the distant mountains is typical of the Chinese tradition. This features the tree, bowed but not broken by the mountain winds.

As a result of these experiences I resonate in a different way with pictorial landscape space. Subtle spacial relationships within my compositions have become more challenging. These insights also helped me teach my Asian art survey course better. Of course, tales from these trips entertained my students.

The Hole In the Wall

During my professional career teaching at Appalchian State, I attended a small Episcopal church just off campus. A small older building, it had a hole in the wall, to the left of the sanctuary arch. Originally it had held the stove pipe coming from the pot-bellied stove that heated the church, which seated about 90 people. A religious tapestry usually hid the opening, which was covered with a few wooden slats.

As visual ideas formed in my head, I started a series of paintings, 48" h x 36" w. After experimentation I was able to work out several basic compositions using tri-part, strong vertical, and diagonal structures. The hue tonalities were based on the liturgical colors of the church year. Blue symbolized Mother Mary; purple embodied penitence and expectation; red, the color of fire and blood, stood for sacrifice; and green was symbolic of God's creation and of living entities. I painted with the seasons of Advent, Christmas, Epiphany, Lent, Easter, and Pentecost in mind.

Though the religious significances of these pieces were abstract, they made new coverings for the hole in the wall of St. Luke's, changing with the liturgical seasons. The works were painted in the acrylic medium, which dried quickly and could be painted over. After studying them and experiencing them during the

page 129

page 130

page 131

services, at the end of that liturgical season, I would take them back to my studio-home for further development.

Lent inspired a development that involved several changes. The first version, in 1995 (see page 129), was subdivided with two diagonals from opposite corners, crossing in the center. The bottom triangle formed a mountain in my imagination, and the top triangle formed heaven, coming down to touch the mountain top. Stabilizing the diagonals is a vertical green-to-yellow band split by a horizontal dark purple band, thus forming a cross. Three concentric circles intersect and further subdivide the shapes.

During the Lenten season I gradually realized that the purple horizontal was too strong and the yellow tones at the top created a searchlight effect. For the 1999 appearance (see page 130) I toned down those exaggerations. I repainted the dark purple to a lavender color so it blended with its surrounding tones. I covered the yellow with compatible pinks, and I painted a thin red cross in the center.

I brought the better of the series with me to Iowa City. The Lenten painting was exhibited at Trinity Episcopal Church in the parish hall for a month in 2002. Afterwards, I restudied the center section, took out the red cross, and developed more intricate triangular shapes, adding more shades of green (see page 131).

At Oaknoll, some of these works have been placed on the wall at the end of long corridors; one simply walks toward the painting, enjoying shapes, colors, and nuances as one draws closer.

One former resident of Oaknoll, who lived on the floor where the red Pentecost painting (see page 128) from this series was hanging, pointed out the angel that she saw within it. She frequently referred to her Guardian Angel when we encountered each other. She had experienced a near-death episode and lived her remaining years in special gratitude with her family.

page 128

Embedded within nature and art forms there exist subtle transformative qualities. Most of us have experienced the radiant, glowing colors that dazzle as sunlight streams through stained-glass windows. Even plain glass windows, framing a mountain view or wooded landscape, yield unexpected delights; they just happen. I can adjust relationships within a composition and work them until the resolution is "just right." If the arc to the transcendental does take place, it is a gift.

Poet Mary Oliver expresses what I mean in the first five lines of her poem, "Drifting":

I was enjoying everything: the rain, the path
 wherever it was taking me, the earth roots
 beginning to stir.
I didn't intend to start thinking about God,
 it just happened.

From Blue Horses *(Penguin Press)*

Meditation on the Garden at Twilight

Twilight and the early hours of the evening, hold special qualities for me. As daylight fades, stillness grows as Earth slips into darkness. When I taught art classes at Appalachian State, I would gratefully return home in the evening. As the sun dipped down, I would walk in the horseshoe-shaped garden on the adjoining lot that extended my property. Gardeners had helped me develop a horticultural environment with borders of flowers. These topped natural stone retaining walls since my property occupied a hillside. With a background of pine trees, I would inhale the cooling air. Those moments were especially cherished when I could be alone, listening to the quieting world. The colors of the flowers would gradually be absorbed by the evening dusk as I walked around the garden.

page 132

The flowers varied according to the seasons. In the spring, daffodils lined the lower walkway as the forsythia bushes burst forth at the far end. Three steps, formerly railroad ties, led to an upper level that featured annuals and Siberian iris. My father had brought those bulbs from his Ithaca garden, along with the fall-blooming burnt sienna button chrysanthemums. As the last blooming flowers of the season, these chrysanthemums arched down over the stone wall. Their curves echoed the curving structure of my meditation garden. I recall with gratitude the respites of peaceful beauty at the close of an active day.

page 133

Daffodils

There was a forecast of an early April snow. A planting of miniature daffodils were in bloom. To protect them I covered them with a clay pot. The next morning, as I lifted off the pot, I discovered those tough yellow blossoms still erect on their stems. As the sun came up, I photographed them. The sheltering pot had created a small circle of spring within a blanket of white snow.

Earlier in my life a similar experience had occurred as I walked back home from Ithaca High School. I beheld the giant maple tree in our neighbor's yard. There had been a light snow during the overcast day. The delicate flakes caught upon the emerging leaves, leaving a circle of green grass with early May flowers glistening in their freshness. I caught my breath as I reveled in the beauty of this unexpected sight.

page 134

Meditation on Line

The vertical line has always intrigued me. I grew up with two tall parents and a tall sister; I had my height of six feet one inch by the time I was 13. Subconsciously, the vertical line, implied, if not drawn, occurs in my artworks. Even in the garden of my Oaknoll apartment, I favor a tall canna as a vertical accent in the center of my large container pots. A real joy was nurturing a six-foot-plus cluster of dark pink lilies named "Black Beauty." They are planted at the back of my garden up against the glass of my four-season porch, visible through the porch window.

The intaglio print from 1990, *Yucca* (see page 107), with its strong upward thrust of the flower stalk exemplifies this interest. Behind it, the varying pattern of dark to light values play with the rhythm of the vigorous leaves. The dominant group of dark leaves is on the left side of the flowers; intermediate tones cluster within the lower right vegetation with upthrusting light gray leaves veiled as if in a morning mist.

page 108

page 107

53

Return to Iowa

A sabbatical year from Appalachian State in 1988–1989 took me back to the School of Art and Art History in Iowa City, studying with Virginia A. Myers and Keith Achepohl. Both had been teaching assistants of the master printmaker Mauricio Lasansky. Now they were professors of printmaking in their own right. They encouraged my presence in class as a non-degree student, as did Bob Glasgow, who had joined the faculty from the University of Wisconsin. He taught monotype and lithography.

As part of this sabbatical year and summer, I developed a three-part series based upon protea blossoms. A tropical flower of the thistle family, the intricacies of the feathery petals kept me drawing studies of them. Mother had sent me a floral gift of five protea blossoms, and they served as my models.

Protea I (see page 102) is the simplest, in which slender leaves swirl around the sturdy stem holding aloft the blossom. The delicate leaf textures were achieved by using a sugar lift technique. I also pulled a second edition from the plate using a deep blue pigment in the black ink. The effect is subtle but different. Blue protea has become one of my favorites.

page 102

Protea II (see page 103) is the most dramatic, with the white wave shape rising up on the left and arching over the large flower in the foreground. The dark tones on the right enhance a circular motion, suggesting an undersea existence.

Protea III (see page 104) with the three blossoms proved the most difficult to resolve into a coherent whole. It still seems incomplete to my eye, mainly because there is no definite light-dark pattern to carry one's attention throughout the composition. The visual thought is unfinished; therefore, this work is rarely exhibited.

page 103

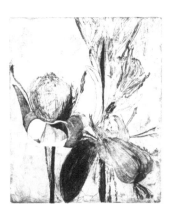

page 104

Meditation on Virginia A. Myers

page 135

Virginia Myers surrounded us with innovative ideas and procedures, urging us to explore them and find new avenues compatible with our own ways of working. Attracted to reflective surfaces since childhood, Virginia had been doing research on authentic silver and gold leaf during her summers when she wasn't teaching at the university.

Commercial printers were using reflective surfaces in a wide range of colors, and Virginia wondered why individual artists weren't using this medium. Discovering that the huge presses were simply too expensive, with their high temperatures and extraordinary pressures, she set out to invent a smaller, hand-held unit. With the assistance of a friend, Dan Wenman, a gifted machinist, and various electrical engineers, Virginia invented a new art tool and named it the Iowa Foil Printer.

Virginia started a class teaching foil imaging in 1990. The students used the early models to adhere leaf foils to prepared papers. If a machine started to smoke, Virginia would call out, "Pull the plug and take the printer outdoors!" After class she would take the faulty printer to Dan's workshop. It would be repaired and ready for use in class the next day. Especially during these concentrated three-week summer sessions, Dan didn't get much sleep.

Gradually, over ten years of devoted labor, the equipment problems were overcome, a UL label procured, and a US patent granted to Virginia for her invention. I continued to come back to her workshops throughout most of the 1990s.

Dad died in 1997 and Mother in 1999 back in Ithaca, NY. After taking care of the estate, I sold my home in Boone to friends, a history professor and his wife who were collectors of art produced by North Carolina artists. My house offered spacious walls for exhibiting art.

Since Boone didn't have a life-care retirement facility, I moved to Asheville, NC, to join one there. During a phone call to Virginia I was complaining about not finding my place within the Asheville community. My mentor just quietly said, "Why North Carolina?"

Upon being accepted at Oaknoll Retirement Residence in Iowa City, I flew one-way from Asheville to Cedar Rapids. Virginia met me at the airport as a snowstorm moved into the area. She graciously housed and fed me until my furniture arrived, five days later.

Discovering a few unoccupied apartments with a northern exposure, the direction offering the most even light for art work, I asked if I could buy one as a studio. Arrangements

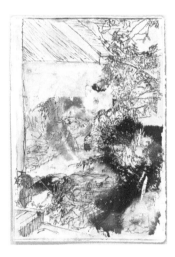

page 136

page 140

page 141

were made and I moved in my art equipment. The studio was on the ground level and a handsome oak tree grew outside the window. Squirrels and chipmunks frolicked up, down, and around its large trunk, providing delightful amusement.

The University of Iowa had become my leit motif; I studied with Virginia for four more years, concentrating on foil imaging. Since I owned an Iowa Foil Printer, foils and other supplies, I could work in my own studio on weekends. During the week, I could concentrate on using the larger equipment and special solvents for intaglio work at the print studio at the university. Virginia guided me in solving tricky foil applications. I had come home.

Eventually, Virginia retired to her home studio in Solon, IA, where she labored with hired assistants developing her five-paneled *Codex for Our Time* (9.5 feet wide x 40"h) and her second book, *Changing Light: A New Visual Language* (WDG Publishing, 2016; completed posthumously). Four of my better works in foil imaging were published in her groundbreaking volumes defining the new art form. *Foil Imaging: A New Art Form* (WDG Publishing, 2001) includes *Emanation* (12" x 9"), p. 173. *Changing Light: A New Visual Language* includes *Blowing PaperLily,* and *Lily,* both pencil and foil, p. 92; and *The Lily* (12.25" x 12.5") intaglio and foil, p. 93.

Foil Imaging

Some of the interest in foil imaging lies in creating various atmospheres using an intaglio image overlaid with different foils. This can be observed in *Blue Conversation, Fragile Life, Bloomed Out, Threatening Flowers,* and *Edge of August.*

I began with an intaglio print in a small edition. I could change the outcome dramatically, depending on the kinds of foil and color stamped on top.

page 113

Blue Conversation (see page 113) features implied interaction between a bulb with tall leaves on the left "conversing" with an animal-like floral form. The far right element is a staff and pennant, lending a festive tone. Purplish blue foil layers float and interact with one another, accented with highlights of orange foil.

In *Fragile Life* (see page 114) a white pigment foil covers the leafed bulb shape on the left and the staff on the right. The subject is the central plant, with attention drawn to a whitish flower by transfer-drawing new strokes of thick yellow and wiry red foil lines below the shades of light green leaf shapes at the top. The feeling is springlike.

page 114

Whereas *Blue Conversation* contains the implied circle with

page 115

page 116

page 117

60

its composition, *Bloomed Out* (see page 115) implies an X formation only by changing the foil colors. The dark bulb at the lower left edge echoes the darkish pennant flying in the upper right corner, establishing the implied line from lower left to upper right. The orange colors playing against the blues establish an opposing diagonal area. The background yellow foil helps the composition to hold together.

The three images compared above demonstrate variations on a theme. Two others, *Threatening Flowers* (see page 116) and *Edge of August* (see page 117), stand as further departures from the original design. Only by looking closely can one discern the basic intaglio print underneath.

In *Threatening Flowers* the bulb form is blocked out by white pigment foil overlaid with lavender and pink-orange tint foils. The flower head in the center is hollowed out, making a negative space displace the middle of the blossom. Navy blue crackling foil with lighter blue showing through encircles the lightest area, forming a kind of claw. The dark blue colors modulate the whole right side, but at the bottom a startling red blossom with pink and orange parts near it provides a strong accent.

Edge of Autumn continues this exploration with overlays of different blue foils on top of orange-toned ones. By laying down dark, blue-purple foil and drawing on it with a blunt pencil,

calligraphic leaf and flower shapes appear on top of the blue and orange foil areas. A warm-toned diagonal path leads the attention back in to the depths of the pictorial space, suggesting a walkway through a wind-blown autumnal landscape.

Postscript to this series: As sometimes happens in working with a composition, the artist recognizes the essence of the print is contained within just one part. I found this in *Spring Emerging* (see page 118). Alone, the leafing bulb is stronger in its upward thrust. I cut the plastic plate.

Postscript to foil imaging: Even though the same basic image can change with different foils, the image can also change in one's view simply because of shifting light acting within iridescent foils. For example, see *Tulip Land II* (see pages 138 and 139)—one artwork, photographed twice, the light playing in a new way.

page 118

page 138

page 139

61

One morning, as I sat at breakfast in the Iowa Memorial Union,
I became absorbed in the Iowa River view outside the window.
Close to the sidewalk a young sapling tree tossed its branches
in the blowing wind. This movement contrasted strongly with
a solid post holding a spherical lamp. I sketched the image.
Later, I developed it as an intaglio print on a square piece
of plexiglass. Dremel tooled lines started the experimental
techniques in this image. Then the earth mound was created by
pressing the core of corrugated cardboard, soaked in methylene
chloride (a solvent agent no longer allowed in printmaking
studios) into the lower portion of the plexiglass. Aesthetically,
the whipping lines of branches contrast well with the dark
texture of roughened plastic, suggesting a cross-section of earth.

I printed a small edition from that plate. I tried laying down
both a gold and a silver foil background before printing the
intaglio on top.

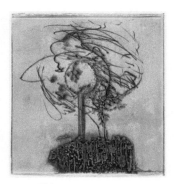

page 120

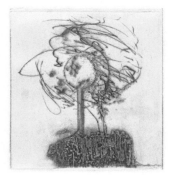

page 121

Meditation on Roundness

At Oaknoll along the corridor wall on the third floor are grouped three of my smaller works: *Tree Blowing* (see page 121), *Shell* (see page 143), *Floral Delicacy* (see page 119). They are all intaglio prints but with different subject matter.

Tree Blowing appears quite circular, with the globe sidewalk lamp and wind-blown sapling branches behind it. It is printed on a silver leaf foil background.

Shell is an intaglio work with etched lines forming the dark background and center of the shell. The outside edges are lighter tones of gray modulating to define the curving flare of the conch shell.

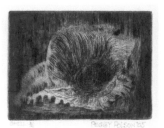

page 143

Floral Delicacy is a color print that involved three plastic plates. The textured yellow background is achieved through small bubble wrap cut out in the shape of a foxglove flower stalk, pressed into yellow ink and then run through a press on dampened printing paper guided by the plate mark established earlier on the paper. The second plate, thin lines cut with a Dremel tool, was inked with a red ink wiped and printed over the yellow background. The delicate navy blue flowerets and grasses were printed from the third plate overlapping the ballooning blossom in the center. At a literal level the tree is a

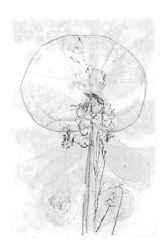

page 119

tree; the post with the globe, a lamp; the shell, a home for the conch; and the foxglove, a variation of its flower.

As I have thought about the subtle roundness appearing to connect these three different works, I have recalled my 1987 charcoal drawing, *Turnips (see page 99)*. Plump, form-defining lines (charcoal used on its side) contrast strongly with the tap roots made by using the end of the charcoal stick.

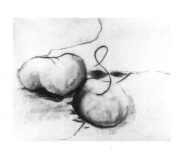

page 99

Vincent Van Gogh wrote that life is probably round. Noting that and expanding upon it, Gaston Bachelard wrote, "The round being propagates its roundness, together with the calm of all roundness." (From *The Poetics of Space*, translated from the French by Maria Jolas; [Boston: Beacon Press]. Translation ©1964 by Orion Press Inc., page 239.)

With a flutter of feathers the robin disappeared into the center of the circular cluster of leaves. My recently planted dwarf Korean lilac tree now contained a nest. Later on, with much coming and going by two robins, I understood that the little birds had hatched. Once, the mother bird dive-bombed me when I came too close to the base of the tree trying to water it. Several evenings later when I threw a bucket of water at the base of the tree, a fledgling fluttered up from the mulch. I gasped as it skittered across the gravel and huddled down at the

base of a sculpture against an opposite wall. Inside I checked on the bird from my bedroom window. It had returned to the base of the Korean lilac and was eating morsels found in the mulch.

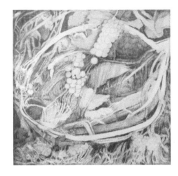

page 148

Now that the fledglings had gone away on their own, I missed my family of robins; however, I felt gratified that the young tree provided acceptable shelter. Each time that I look at the recent pencil drawing, *An Inner Eye of Nature* (see page 148), with a dove nestled deep within the vine's branches, I am reminded of this quiet adventure. I had admired the appearance of the dwarf Korean lilac and especially delighted in its fragrance in the spring, yet the birds dwelling within it gave it a richer, fuller meaning. And another unexpected sense of roundness had happened. https://us02web.zoom.us/j/9707364697

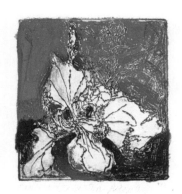

page 122

Meditation on Blue

Born with blue eyes, I have grown up enjoying clothing that accents their color. Periwinkle is a favorite.

Upon my retirement to Iowa City, I enrolled in a body movement class where we exercised on the floor. The cork-linoleum was blue with a labyrinth in cream lines embedded within its surface. I enjoyed lying on that floor, a blue field, gazing up through the top of the tall windows at the azure sky, clouds floating by, interrupted by the flights of birds. Later, in my studies of Jungian psychology, I discovered that the meditative process is associated with the color blue.

I painted several blue paintings in the 1960s; one of them was done in Paris of the grand view out the living room window of the Joba apartment. It overlooked the Renault auto factory built on an island located in the middle of the Seine. I remember gazing out at night along the opposite hill, up over the lights of the densely crowded city, the view culminating in the glistening dome of Sacre Coeur, white against the blue-black of the night sky.

I remember one Paris art museum visit when I came face to face in a stairwell with Van Gogh's painting *The Church at Auvers-sur-Oise*. I marveled at the rich blue sky which

vibrated with explosive energy that I felt in my core. Studying Kandinsky, I found that in *Concerning the Spiritual in Art*, he states that "in music a light blue is like a flute, a darker blue a cello; a still darker the marvelous double bass; and the darkest blue of all—an organ."

✍

I started a blue painting several years ago with thoughts of evoking the cosmos with spiraling galaxies. I worked on it at various times, stroking and brushing into the canvas red-orange colors, followed by three blues: pthalo, cobalt and cerulean, painted lines crisscrossing each other. The red-orange colors showing through suggested the fiery depths of a volcano. As I lived with the image, I observed that the composition didn't work.

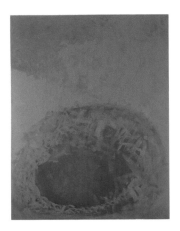

page 152

After much study I began to discern a vague heart shape trying to emerge from the volcano that was in an area located too low in the composition. With the three blue paints, I "lifted" the lower left corner and modified the shape to allow the heart image to appear. With this visual resolution arrived the title, *The Heart of Blue* (see page 152).

An Inward Journey with
Pierre Teilhard de Chardin

The work of Pierre Teilhard de Chardin has attracted me ever since I read an article about him while at a laundromat in Plattsburgh, NY. I had been teaching design to art students at the State College in that community, 1963–1966. This man's scientific labors in geology/paleontology accompanied by his faith journey fascinated me. That article helped me answer a quandary I had experienced listening to a lecture at Cornell University where two professors vigorously debated the merits of theology versus science. I intuitively felt that these areas of knowledge were not opposites but different approaches to the comprehension of life.

page 126

Early in my teaching career at Appalachian State University, geology professor Ken McKinney said, "Peggy, you must read this!" It was a translation of Pierre Teilhard de Chardin's *The Human Phenomenon*. As I tried to read it, I found it difficult to understand. Still later, I encountered his written prayer, "Mass on the World," which swept me into the imaginative mind of this earth scientist and Jesuit priest.

Joining the American Teilhard Association increased my awareness of scholars researching his writings. Their clarifications assisted me in better understanding his concepts.

Sometimes his own words helped, especially in the essay "The Function of Art as an Expression of Human Energy":

> A feeling may be vivid, but it still lacks something,
> or cannot be communicated to others, unless it is
> expressed in a significant act, in a dance, a song, a cry.
> …It is art that provides this song or cry for the anxieties,
> the hopes and enthusiasms of man [and woman]. It
> gives them a body, and in some way materializes them.

He went on to observe:

> It is intuition and not reason that should be dominant.
> But if the work does truly issue from the depths of his
> [or her] being, with the richness of musical harmony,
> then we need have no fear: it will be reflected in the
> minds of those upon whom it falls, to form a rainbow
> of light. More primordial than any idea, beauty will be
> manifest as the herald and generator of ideas.

page 125

Teilhard suggested that the artist provides firstly, the "over-plus of life," secondly, "symbolic expression" to experiences, and thirdly, "personalization" of the process. I interpret the "over-plus of life" to be those activities of life beyond what is needed to exist and earn a living. Concerning the "symbolic expression," Teilhard stated, "art thus gives the spiritual energy that is being produced on earth its first body and its first face. . . . [Art] communicates to that energy, and preserves for it, its

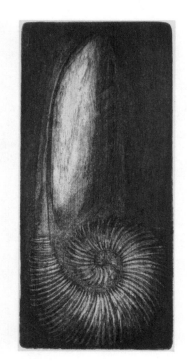

page 145

specifically human characteristic, by personalizing it." Teilhard also pointed out that these artistic interpretations offer a needed balance to offset the forces of our technological world.

Friends have spoken about the sense of "uplift" that they feel from my artwork. They are able to recognize it as they move along the corridors of Oaknoll where pieces are exhibited. (Oaknoll Retirement Residence has inadvertently become a Polson art museum. As each new building has been added, there has been a need for visual art on the walls. My work has joined other artwork that new residents bring.)

The quality of serenity, especially in the pencil works of floral imagery, is my way of expressing the "over-plus" of life in symbolic forms that resonate with my life experiences.

My explorations of painting, intaglio printmaking, and foil imaging have led me back to my early love of using the pencil to explore the objects that attract me within my immediate environment. While I am working and these pieces resolve into a cohesive whole, hopefully with an "uplift" quality, I feel as though a spiritual dimension of my life is being fulfilled.

For Reference: Pierre Teilhard de Chardin, *Toward the Future.* Translation by Rene Hague. A Harvest Book, Harcourt Inc. Copyright ©1973 by Editions du Seuil, arts. English translation copyright ©1975 by William Collins Sons and Co. Ltd. and Harcourt, Inc., pp. 88–90.

Journeying with Thomas Berry

In the early 1970s, as I was driving through Greensboro, NC, en route to Chapel Hill for dissertation conferences with Dr. Dixon, little did I realize that I was passing through the birthplace and eventual retirement home of Thomas Berry. He lectured twice during my tenure at Appalachian State, events I attended. But I was too immersed in my art courses to respond to the breadth and depth of his teaching.

page 149

In the early 1980s, I took a course called "The Journey in Medieval Christian Mysticism" at Fordham University with Ewert Cousins. The class made a trip to Riverdale Center for Religious Research, where Thomas Berry lived. It was a great Victorian mansion of many rooms filled with Berry's huge library. I remember best the famous red oak on the grounds. Under its great limbs Berry spent hours in deep reflection gazing toward the Palisades across the Hudson River.

At the beginning of *The Great Work* Berry described encountering in his youth a meadow of white lilies and its enchanting beauty. That image became deeply implanted within him and became a source of continual inspiration.

How could I not feel kinship with such a person, harkening back to my enchantment with flowers? Lilies are among the plants that made their way to a series of images I explored.

It's only in my own retirement that I have been able to read and reflect more on Teilhard's work and start reading Thomas Berry's thoughts in his books. Berry studied the writings of Teilhard and became deeply impressed by his thoughts on evolution. These enlarged his own vision. As Berry's education moved from theology to history to culture and into studies of evolution, Teilhard's work stimulated him. Berry called himself a Geologian as his studies gradually focused on the earth and its history of evolution. He developed a writing style that would appeal to nonspecialists and be more inclusive. University teaching became his profession as well as the writing of books.

My own spiritual journey has been nurtured by my explorations of nature through gardens where I have lived, and through the various art media that I have explored throughout my life. At first absorbed by the appearance of plants and flowers I have grown to express their inward meaning. "Uplift" resonates, and a deep sense of "rightness" has developed.

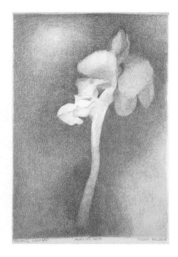

page 150

Thomas Berry in "The Wild and the Sacred" (pp. 48-49 in *The Great Work)* stated:

> … For we will recover our sense of wonder and our
> sense of the sacred only if we appreciate the universe
> beyond ourselves as a revelatory experience of that
> numinous presence whence all things come into being.
> Indeed, the universe is the primary sacred reality.
> We become sacred by our participation in this more
> sublime dimension of the world about us.

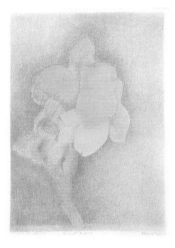

page 151

My artwork has allowed me glimpses of this "revelatory
experience of that numinous presence."

Australian Journey

"Peggy, can you come with us to Australia?"

Marilyn Sparling was on the telephone, calling from Chapel Hill, NC. I gasped and exclaimed, "Let me check with my financial advisor." When I phoned Jillian she said, "Go!"

The Sparlings, with whom I had traveled various places already, were combining business and pleasure. We would spend a week each in Sydney, Melbourne, Adelaide, and Canberra. While Joe and a colleague attended meetings, Marilyn and I headed out to explore art and anthropological museums.

page 112

Separately I became aware that there was another artist Peggy Polson in the world. With the help of a friend's internet skills, Peggy Poulson (British spelling of Polson) appeared—actually Peggy Napurrula Poulson. She was an aboriginal artist living in the Northern Territory of Australia. Marilyn and I ended up researching her work and her life at the various art museums and public libraries. The librarians were exceptionally helpful when they discovered that they were working with another artist Peggy Polson!

The following year, the Sparlings were back in Australia continuing their work and travels. Marilyn inquired at an art

gallery in Alice Springs and learned that Peggy Poulson had not been seen for several years nor brought in any new artworks. They imagined she had returned to the desert interior.

Peggy Napurrula Poulson, my elusive double, I know only through seeing a few examples of her artwork in books and hearing of her participation in group paintings.

Born about 1935, "Peggy Poulson was one of the early women painters whose powerful paintings about women's ceremonial life in traditional Warlpiri society helped to put the new Warlukurlanga Artists company on the artistic map in the mid-80s," stated Vivien Johnson in *Aboriginal Artists of the Western Desert: A Biographical Dictionary*.

page 123

Since Peggy Poulson "is a senior custodian of the Janganpa (Possum), Patanjarnngi, Ngalajiyi (Bush Carrot), and Mantala Dreamings," I became curious as to what these Dreamings were.

Two placards (I transcribed) in the aboriginal exhibit at the Australia Museum, Sydney, help to answer my question:

> Dreaming tracks trace the creative journeys of the Spirit ancestors as they formed the land and laid down the law. Dreaming tracks are sometimes called Songlines and record the travels of the Spirit ancestors who "sung up" the country into life. It is believed that performing the

right songs and ceremonies at points along the Dreaming track gives people direct access to the Dreaming.

Our story is in the land . . . it is written in those sacred places, it is the law. Dreaming place . . . you can't change it, no matter who you are. (Big Bill Neidjre, Gagudju elder, Kakadu, 1986)

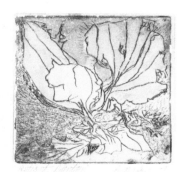

page 111

Born in the South and growing up in the North, I notice with appreciation that my double, Peggy Napurrula Poulson, born in the desert of the Northern Territory and exhibiting her artwork in the Southern cities, experienced the cardinal directions in reverse order. We never met. I have seen examples of her paintings only in reproduction. She has never seen my work. This interesting play upon North–South is part of both of our journeys, especially since my tenured professorship in art extended throughout 21 years in the southern Blue Ridge–Appalachian mountain town of Boone, NC.

Meditation on Tracks and Lines

In my imaginative way, I tried to stretch the concept of
Dreaming tracks to my own family. My sister Marion's family
relationships strengthened through her cancer suffering. Each
one of us tried to be supportive of her needs. My parents carried
the heaviest burdens and the loss of their youngest daughter. An
empathetic visiting nurse used the meditation tone of "Om" to
ease Marion's pain while cleaning the deep surgical wound in
her abdomen.

Songlines sustained my mother. As a singer and teacher she
contributed generously to the community through her music.
Whenever she entered a new space, she wanted to throw out a
tone so that she could "hear" that space.

For my father, an earth-rooted, agricultural Dreaming track
would be appropriate. He was deeply attached to land, from
his youth on a dairy farm, through his longtime gardening
interests, until late in life when he owned 90 acres of woodland,
where he and Mother lived out their lives. To protect that
acreage, the land was deeded to Cornell Plantations (currently
Cornell Botanic Gardens) for plant research.

page 124

Land is so important to our psyches. As the Australian
Songlines root Aboriginals to their ancestral lands, gardening

77

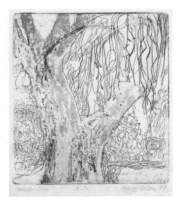

page 101

and tree care rooted my father to his past. I, his elder daughter, in my turn, find solace in the earth, gardening flowers during growing season, and nurturing plants in my living spaces. These experiences have furnished the Dreaming tracks for my artwork . . . "a child of creation of the creator." [1]

[1] Paul Klee, *The Thinking Eye*

Benediction

May the stars carry your sadness away. May the flowers fill your heart with beauty. May hope forever wipe away your tears. And above all, may silence make you strong.

Chief Dan George

Curriculum Vitae: Margaret (Peggy) R. Polson

Education

Ph.D., 1974, University of North Carolina at Chapel Hill, NC

M.F.A., 1961, University of Iowa, Iowa City, IA

M.S., 1956, Cornell University, Ithaca, NY

B.F.A., 1954, Cornell University, Ithaca, NY

A.A., 1951, Stephens College, Columbia, MO

Teaching

1971–1993, Appalachian State University, Boone, NC

1963–1966, State University College, Plattsburgh, NY

1962–1963, Cornell University, Ithaca, NY

1956–1958, Iowa State University, Ames, IA

1955, Roberson Memorial Museum, Binghamton, NY

1953, Silliman University, Philippines

Exhibition Summary

Peggy Polson's artwork has been exhibited in faculty and regional shows where she has been employed. The universities and colleges where her work has been exhibited are Appalachian State University, Winston-Salem College, East Tennessee State University, University of Iowa, University of Georgia, Ithaca College, Lees-McRae College, NC, and Mayland Community College, NC. Her work has been featured at the Carlton Gallery of Creekside Galleries in Banner Elk, and the

Jones House Community Center in Boone. In addition, she has participated in group shows at the Asheville Art Museum, the Mint Museum, Southeastern Center for Contemporary Art, and two traveling exhibitions in the Midwest. She has studied art in Mexico and Europe. For six weeks in 1985, she studied Chinese calligraphy and landscape painting at the Zhejiang Academy of Fine Arts in China.

Since her retirement to Iowa City in 2000, she has exhibited her work at the Artisans' Gallery, Chait Galleries Downtown, and with Arts Iowa City. Some of her artwork is on permanent exhibit where she lives at Oaknoll Retirement Residence.

Papers Presented
"Meditations on the Numinous as Revealed through Trees, Rocks, and Water." One of five on the panel "The Nature of the Numinous: Trees, Rocks, and Water."
Chair: Leslie Klein. Southeastern College of Art Conference, October 27–29, 1988, Rollins College, Winter Park, FL.

"Archetypal Tree: A Coincidence of Opposites as Revealed through the Works of Various Artists." One of four on the panel "Jungian Approaches to Meaning in Art." Chair: Sharon Hill. Southeastern College of Art Conference, October 15–17, 1992, University of Birmingham, Birmingham, AL.

Artworks by Peggy Polson

(Placed in approximate date order, with references to earlier pages only if the work is discussed there.)

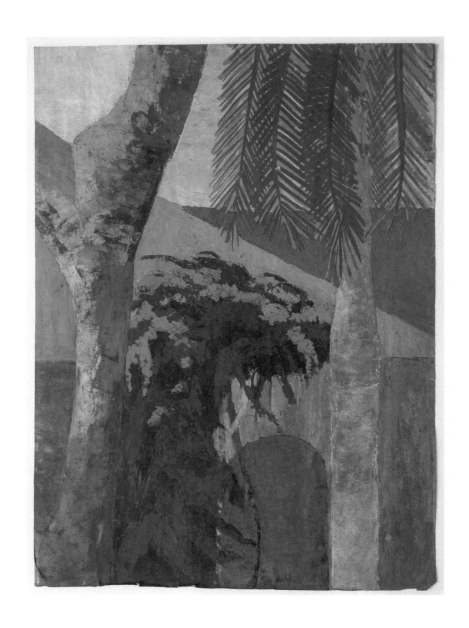

Bougainvillea Vine, 1953, casein paint on paper, ca. 14 x 10 in. *(see page 28)*

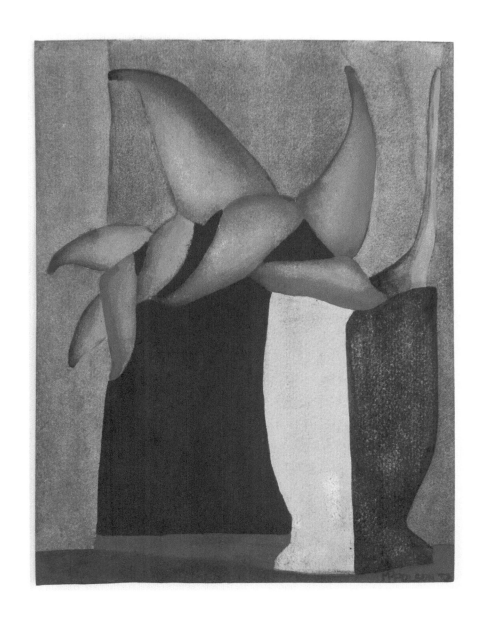

Ginger Flower, 1953, casein paint on paper, ca. 14 x 10.5 in. *(see page 28)*

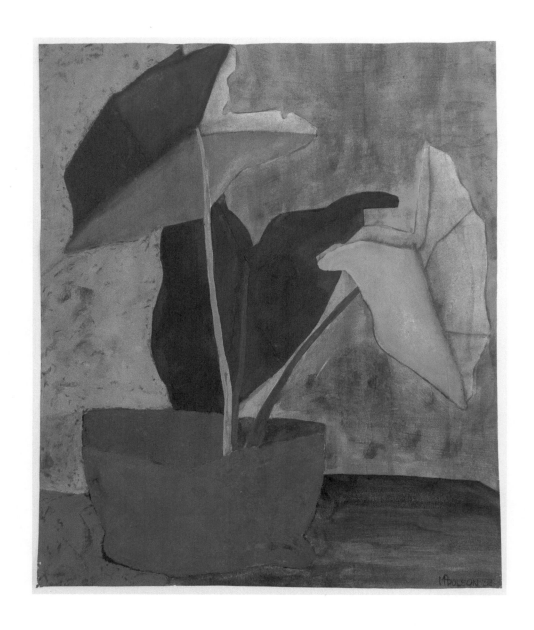

Caladium Leaves, 1953, casein paint on paper, ca. 14 x 11.5 in. *(see page 28)*

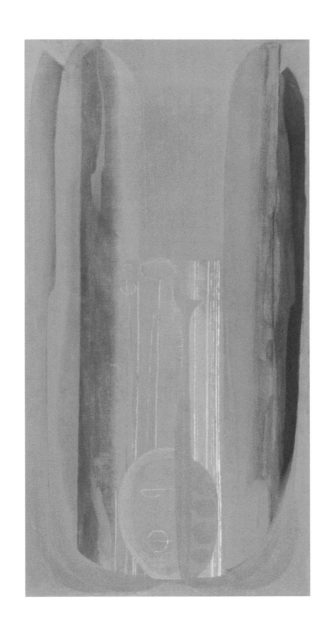

Red Tulip Flower, 1954, oil, ca. 36 x 17.75 in. *(see page 29)*

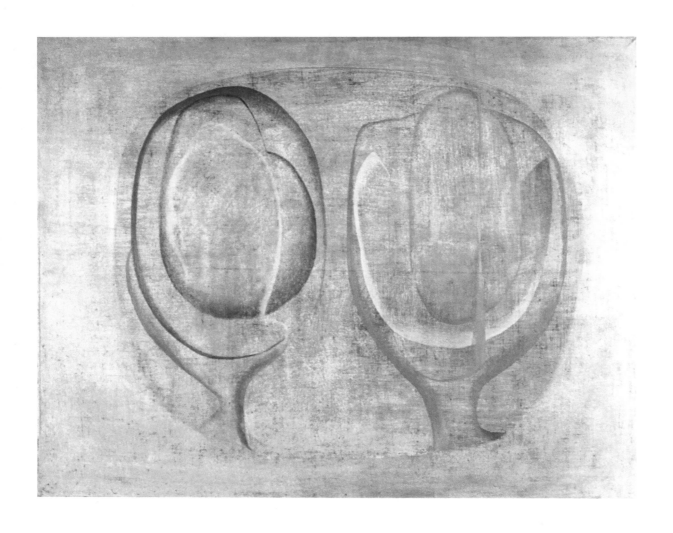

Green Painting with Two Floral Heads, 1954, oil, ca. 24 x 30 in. *(see page 30)*

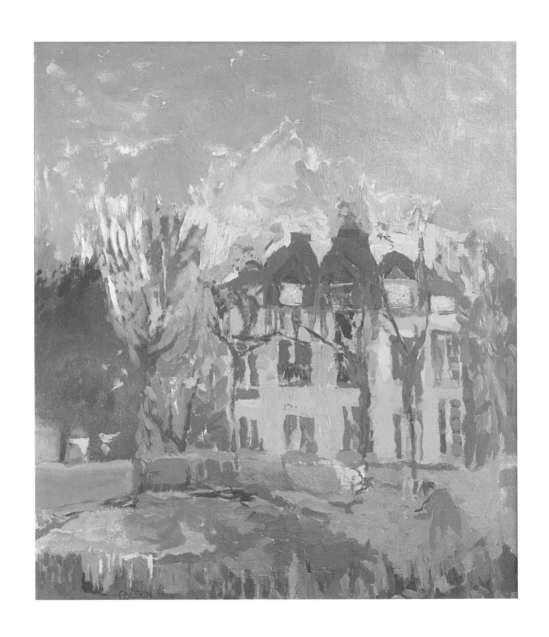

Red House, 1963, oil, ca. 37 x 31 in. *(see page 36)*

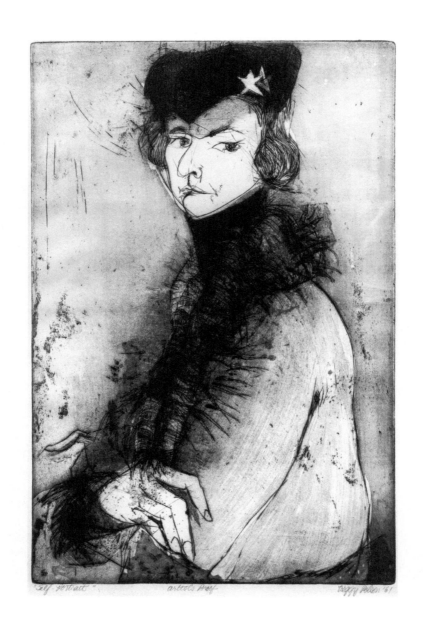

Self-Portrait, 1961, intaglio, 23.5 x 14.75 in. *(see page 33)*

Searching, 1964, carbon pencil, ca. 24 x 16.5 in.

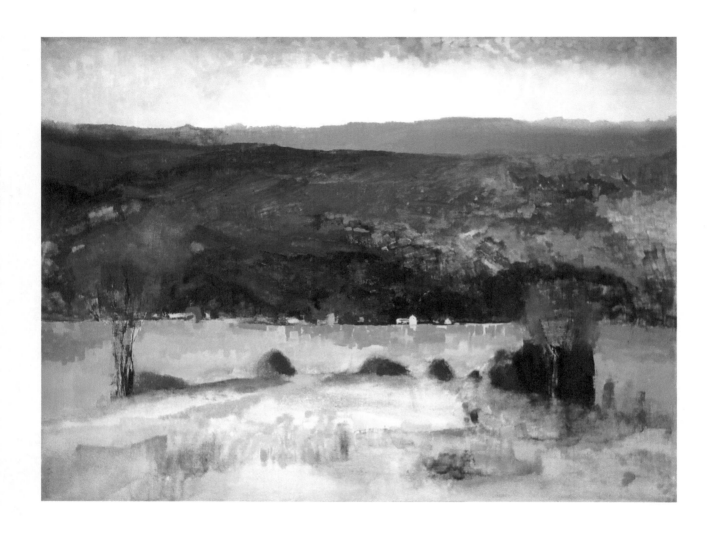

Cayuga Landscape, 1966, oil on panel, ca. 36 x 48 in. (*see page 22*)

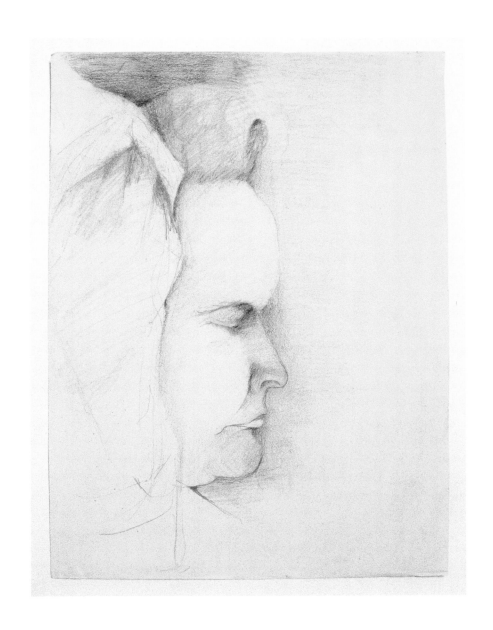

Marion, c. 1972, pencil, ca. 12 x 9 in. (*see page 23*)

"Butter" under a Bush, 1974, ink drawing, ca. 6 x 3.5 in. *(see page 40)*

Floral Gem, 1985, mixed media, ca. 9 x 6 in.

Canal Houses in Shaoxing I, 1985, watercolor, ca. 9 x 12 in. *(see page 45)*

Canal Houses in Shaoxing II, 1985, watercolor, ca. 9 x 12 in. *(see page 45)*

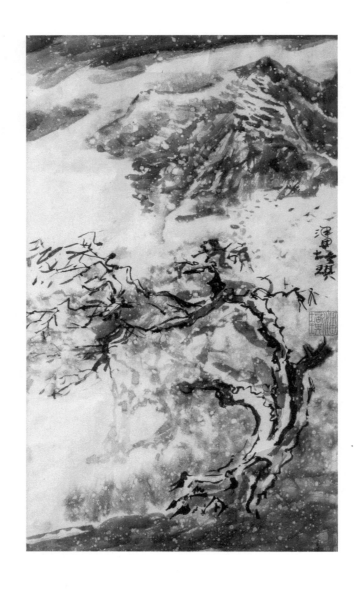

Winter, Pine Tree, and Mountain, 1985, ink, ca. 26 x 13.25 in. *(see page 46)*

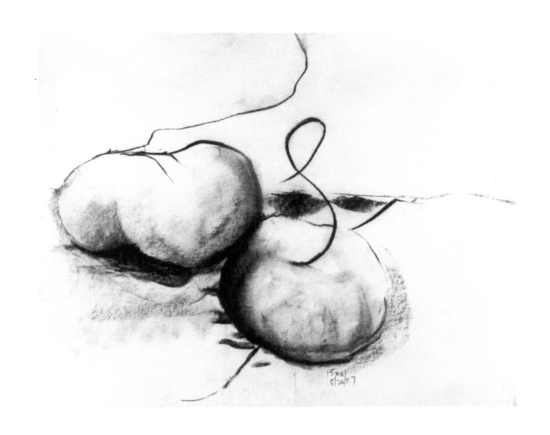

Turnips, 1987, charcoal drawing, 18 x 24 in. *(see page 64)*

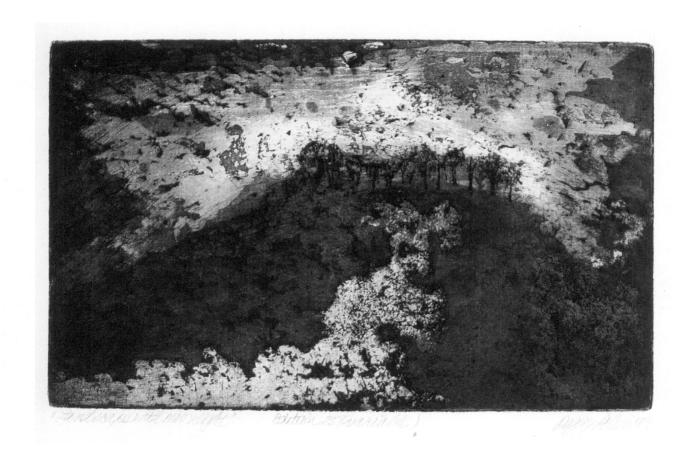

Landscape with Moonlight, 1989, aquatint intaglio, edition of 25 variable, 6 x 9 in. *(see page 42)*

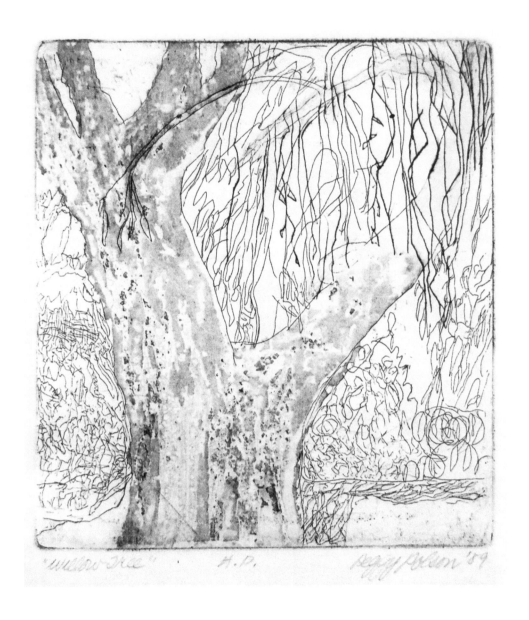

Willow Tree, 1989, intaglio, 7.25 x 6.25 in.

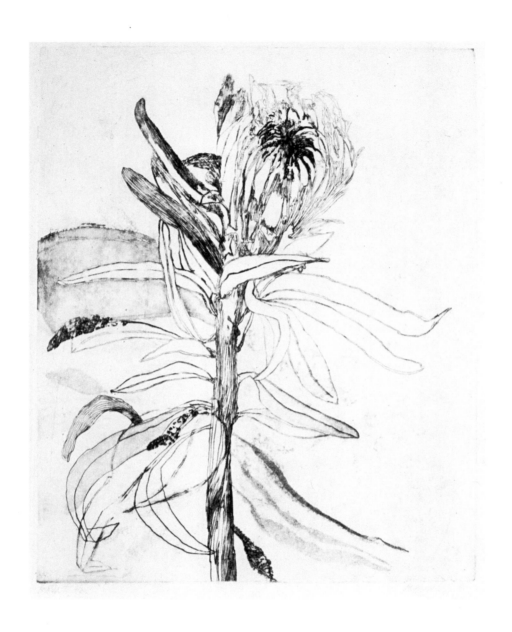

Protea I, 1990, intaglio, edition of six, 28 x 24.25 in. *(see page 54)*

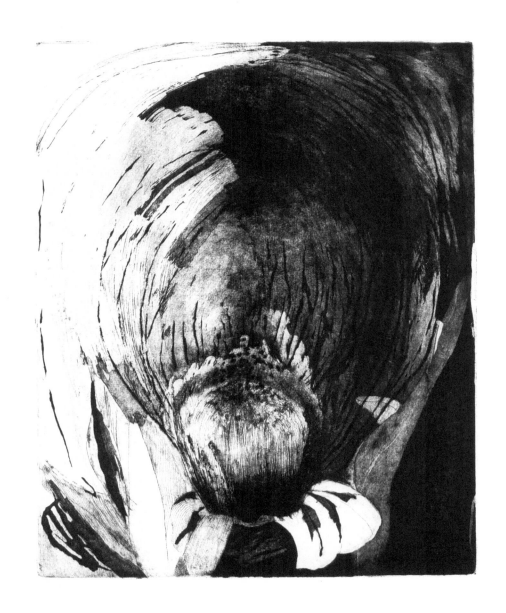

Protea II, 1990, intaglio, edition of six, 28 x 24.25 in. *(see page 55)*

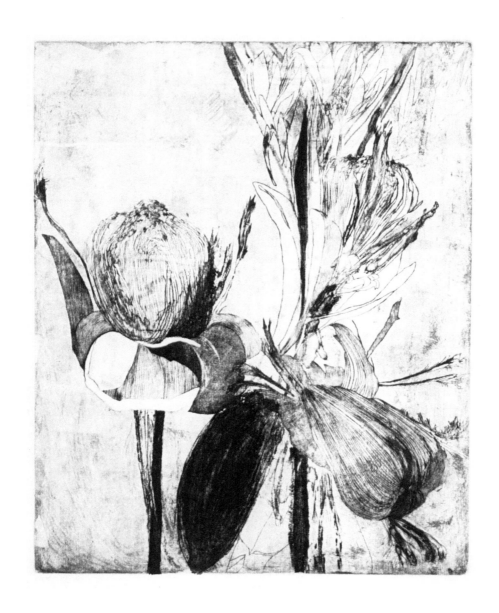

Protea III, 1990, intaglio, edition of six, 28 x 24.25 in. *(see page 55)*

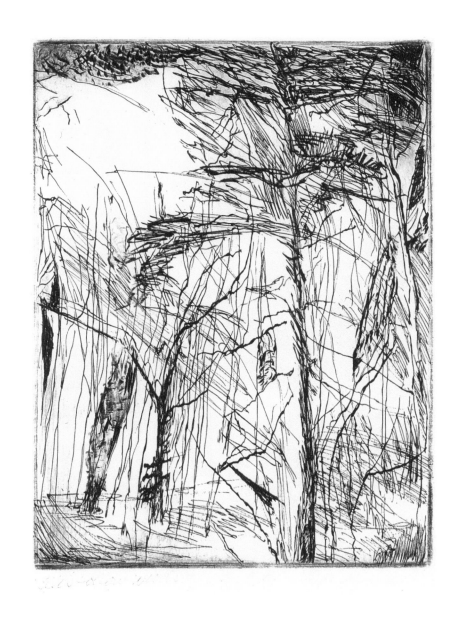

Ellis Hollow Woods I, 1989?, intaglio, 8.5 x 6 in. *(see page 25)*

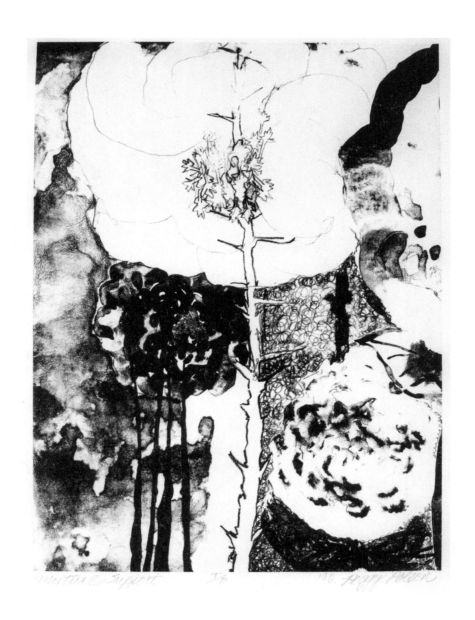

Mutual Support, 1992, lithograph, 11.5 x 8.5 in.

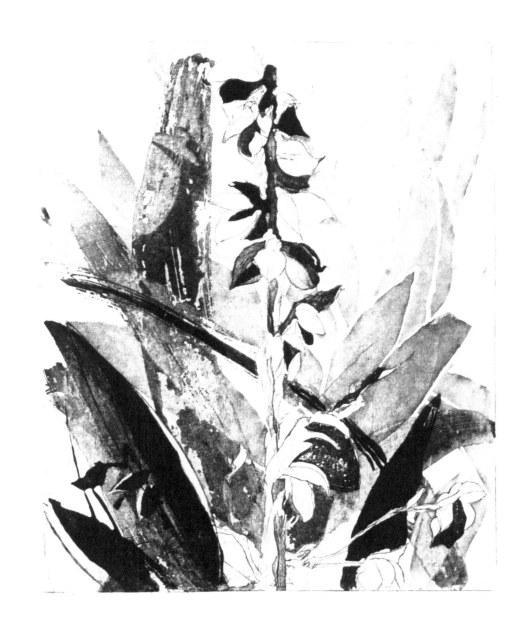

Yucca, 1989, intaglio, edition of 14, 19.5 x 15.75 in. *(see page 53)*

Yucca Study II, 1992, intaglio, ca. 10.5 x 8 in.

Floral Meditation I, 1992, intaglio with foil stamped monotype, ca. 5 x 5.5 in.

Floral Meditation II, 1992, intaglio with foil stamped monotype, ca. 5.25 x 4.5 in.

Reticent Plantain, 1993, intaglio with foil stamped monotype, ca. 5.25 x 5.25 in.

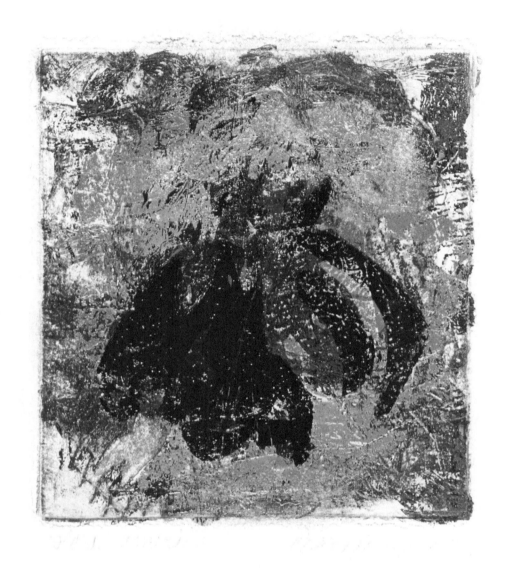

Floral Ambiance, 1993, intaglio with foil stamped monotype, ca. 5 x 4 in.

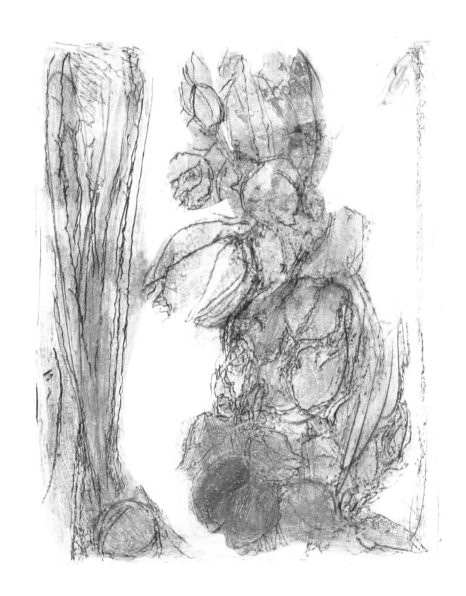

Blue Conversation, 1993, intaglio with foil stamped monotype, 12 x 9 in. *(see page 59)*

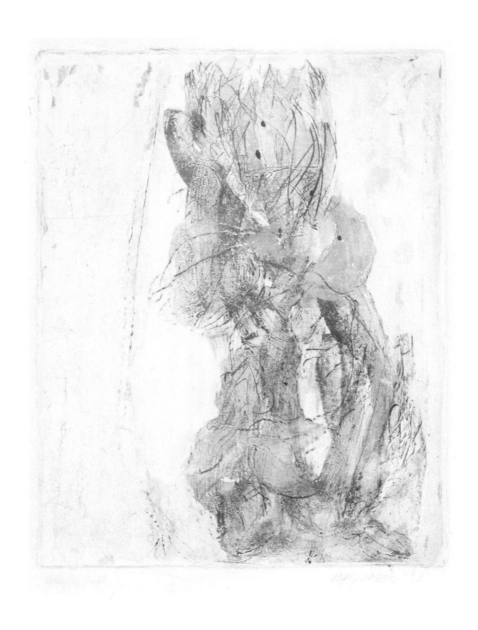

Fragile Life, 1993, intaglio with foil stamped monotype, 12 x 9 in. *(see page 59)*

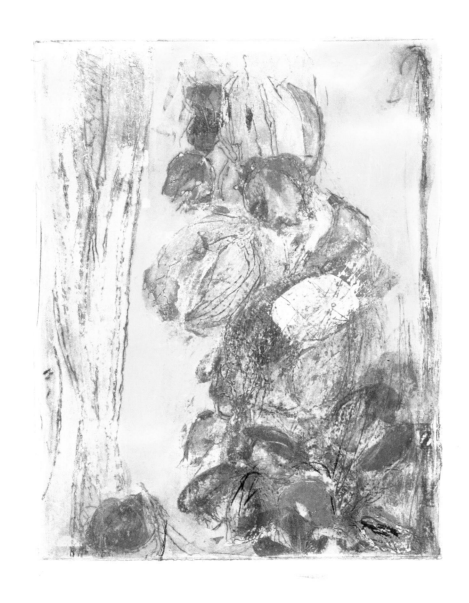

Bloomed Out, 1993, intaglio with foil stamped monotype, 12 x 9 in. *(see page 60)*

Threatening Flowers, 1993, intaglio with foil stamped monotype, 12 x 9 in. *(see page 60)*

The Edge of Autumn, 1993, intaglio with foil stamped monotype, 12 x 9 in. *(see page 60)*

Spring Emerging, 1993, intaglio with foil stamped monotype, 12 x 3 in. *(see page 61)*

Floral Delicacy, 1993, intaglio with foil stamped monotype, 8.25 x 5.25 in. *(see page 63)*

Tree Blowing, 1993, intaglio on silver foil, 6.5 x 6 in. *(see page 62)*

Tree Blowing, 1993, intaglio on gold foil, 6.5 x 6 in. *(see page 62)*

Exuberant Plantain, 1993, intaglio with foil imaging, 5 x 4.5 in.

Visage from the Past, 1993, intaglio with foil stamped monotype, 12 x 9 in. *(see page 75)*

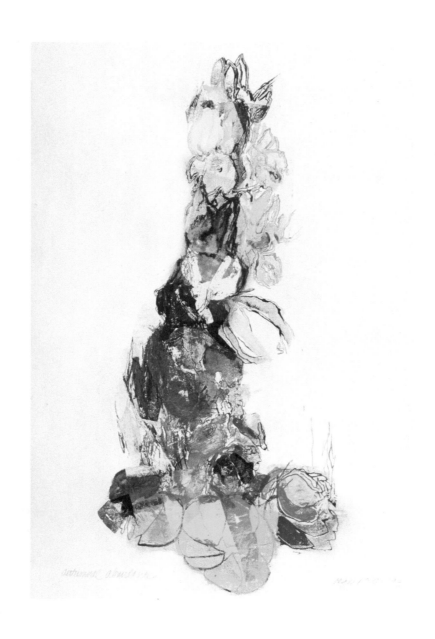

Autumnal Abundance, 1993, foil stamped monotype, 25 x 18 in.

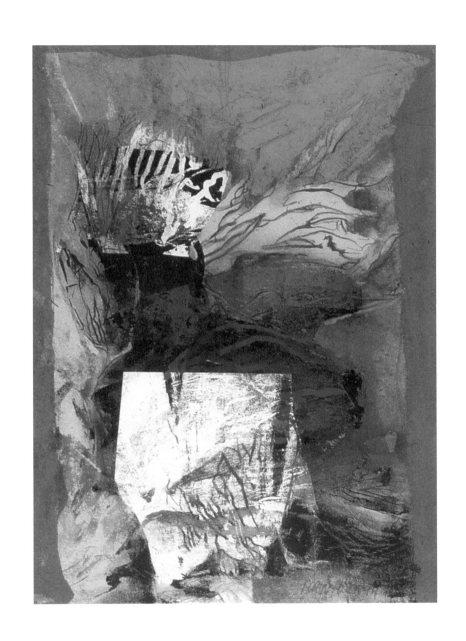

White Glass in Window, 1994, foil stamped monotype, 14.5 x 10 in.

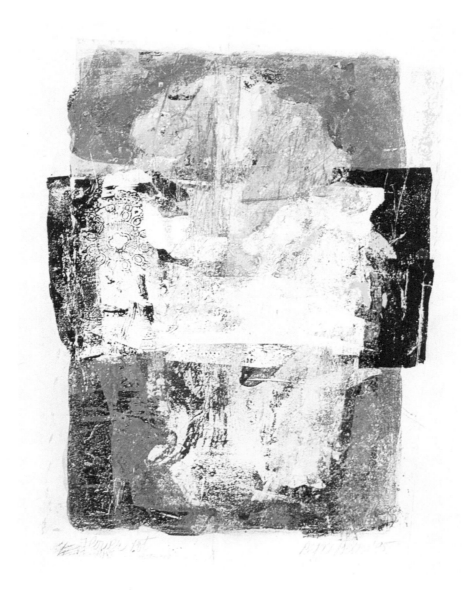

Flower Pot, 1995, foil stamped monotype, 10.25 x 8.25 in.

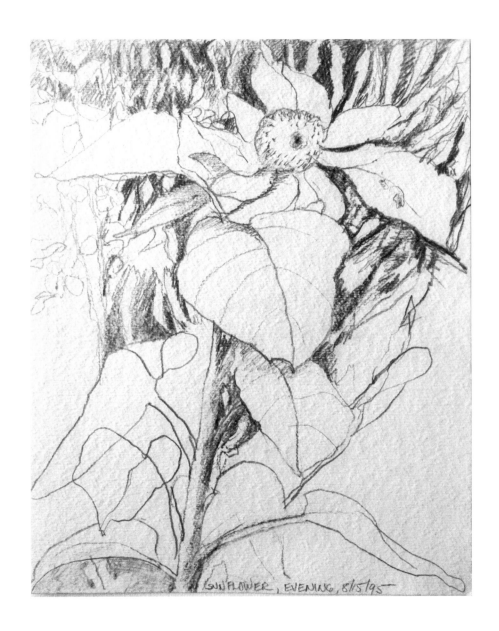

Sunflower, Evening, 1995, graphite, ca. 12 x 9 in.

Pentecost, 1994, acrylic on canvas, 48 x 36 in. *(see page 49)*

Lent, 1995, acrylic on canvas, 48 x 36 in. *(see page 47)*

Lent, 1999, acrylic on canvas, 48 x 36 in. *(see page 48)*

Lent, 2004, acrylic on canvas, 48 x 36 in. *(see page 48)*

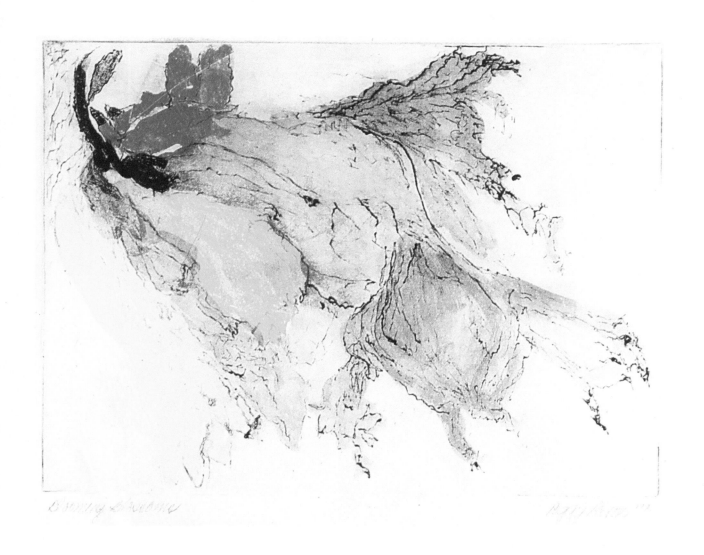

Blooming Blossoms, 1994, intaglio with foil stamped monotype, 9 x 11.5 in.

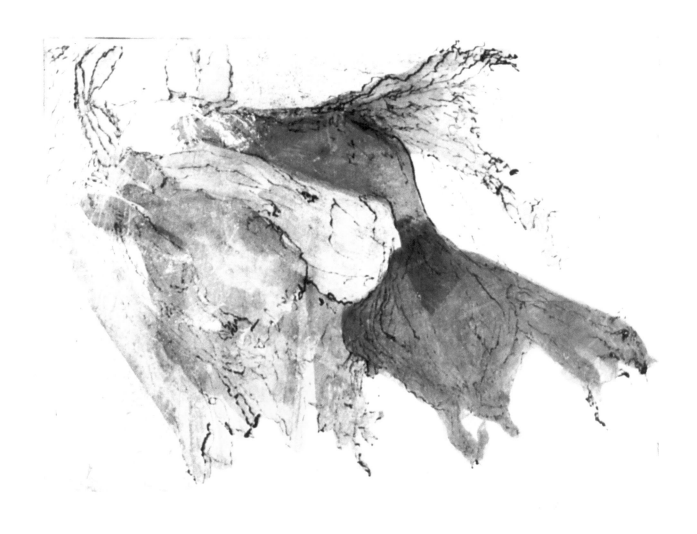

Ephemeral Blossoms, 1994, intaglio with foil stamped monotype, 9 x 11.5 in.

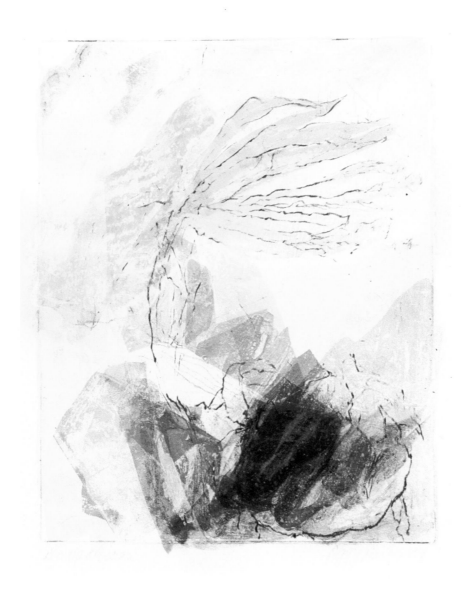

Blowing Blossoms, 1994, intaglio with foil stamped monotype, 12 x 9 in.

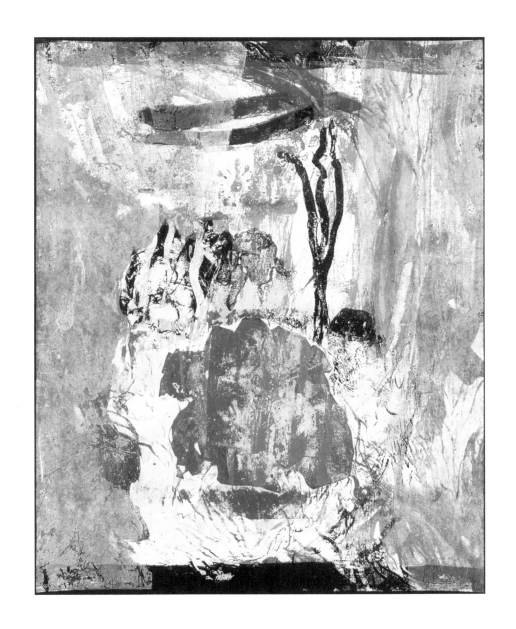

The Vista, 1994, foil stamped monotype, 15.25 x 12.25 in.

Wind Energy, 1997, intaglio with foil stamped monotype, 11.5 x 7.25 in.

One, 1999, intaglio, 5.25 x 3.25 in.; *Two,* 1999, intaglio, 5.25 x 3.25 in.

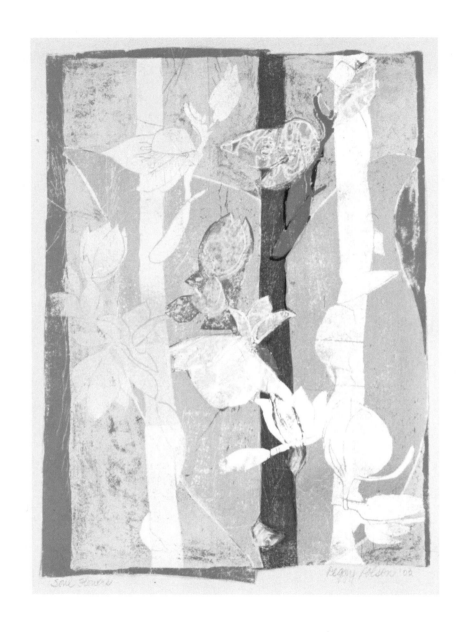

Tulip Land II, 2002, foil stamped monotype, ca. 12 x 8.5 in. *(photo a; see page 61)*

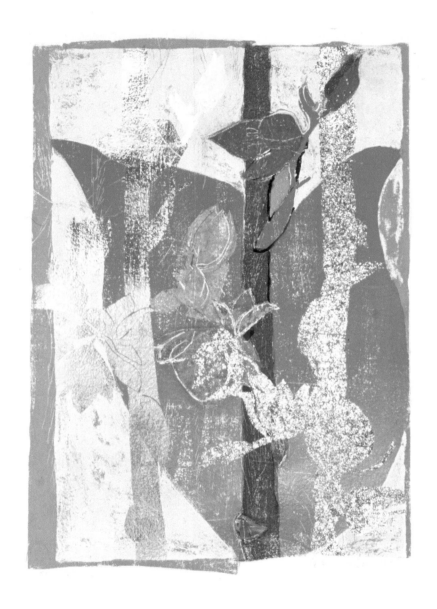

Tulip Land II, 2002, foil stamped monotype, ca. 12 x 8.5 in. *(photo b; see page 61)*

Chipmunk Eating, 2004, ink sketch, 6 x 6 in. *(see page 58)*

Oak Branch, 2004, ink sketch, 6 x 6 in. *(see page 58)*

Two Tulips, 2002, graphite, ca. 12 x 9 in.

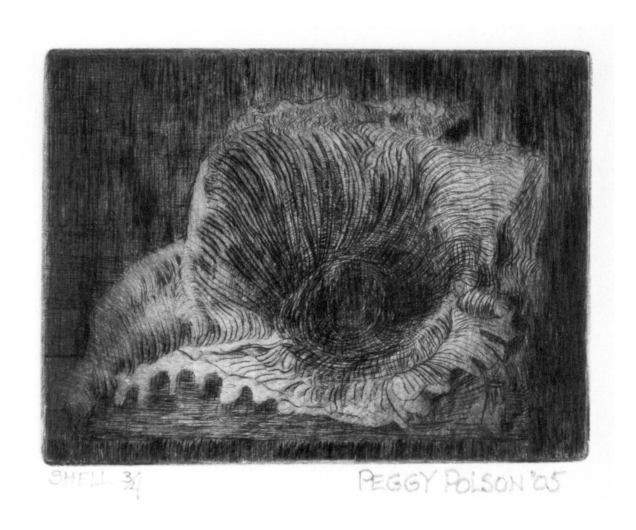

Shell, 2005, intaglio, 6 x 6 in. *(see page 63)*

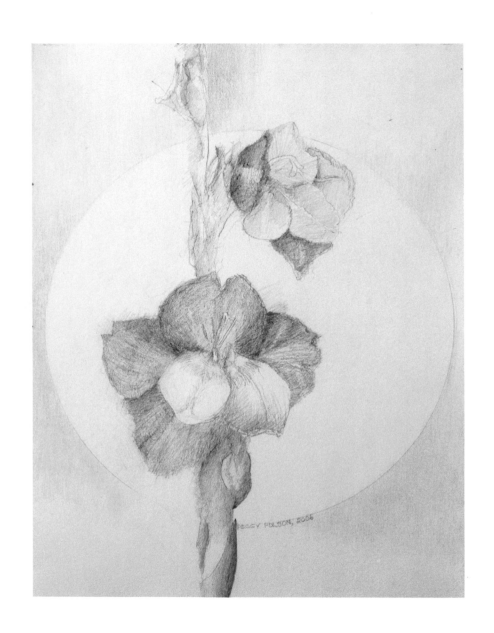

Gladiolus, 2006, graphite, ca. 12 x 9 in.

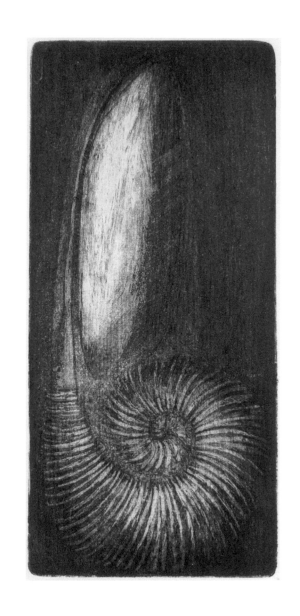

Chambered Nautilus, 2005, intaglio, 11.5 x 5 in.

Night, 2013, graphite, ca. 8.5 x 11.5 in.

Day, 2014, graphite, ca. 8.5 x 11.5 in.

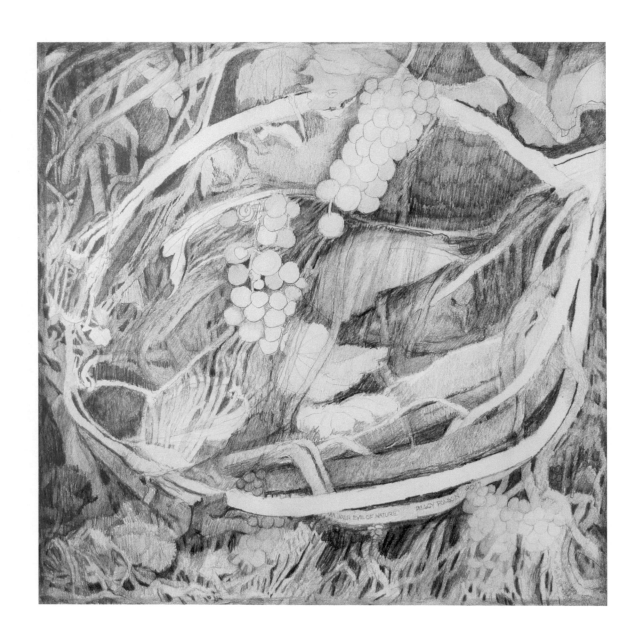

An Inner Eye of Nature, 2017, graphite, 19 x 19 in. *(see page 65)*

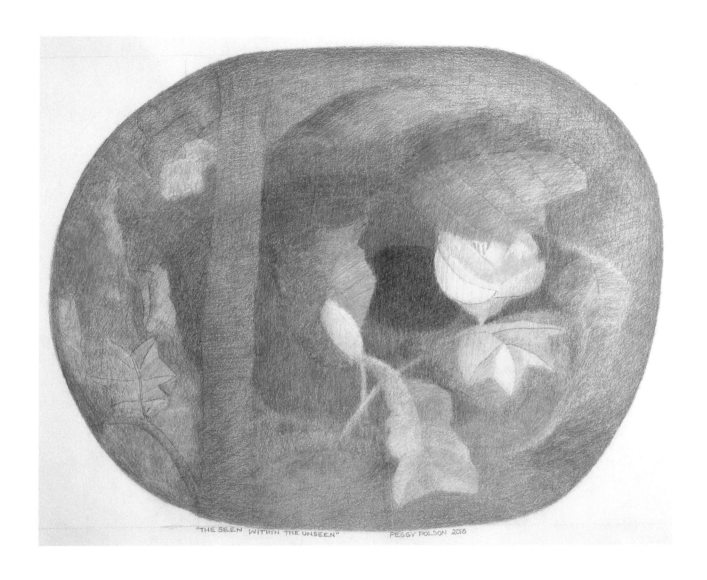

The Seen within the Unseen, 2018, color pencil, ca. 20 x 27.5 in.

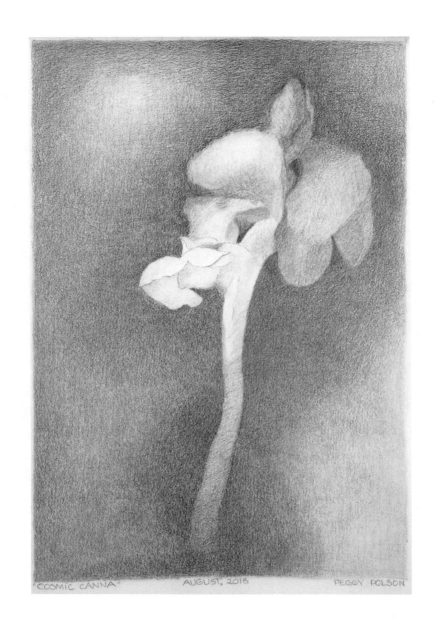

Cosmic Canna, 2018, graphite, 19.5 x 12.75 in.

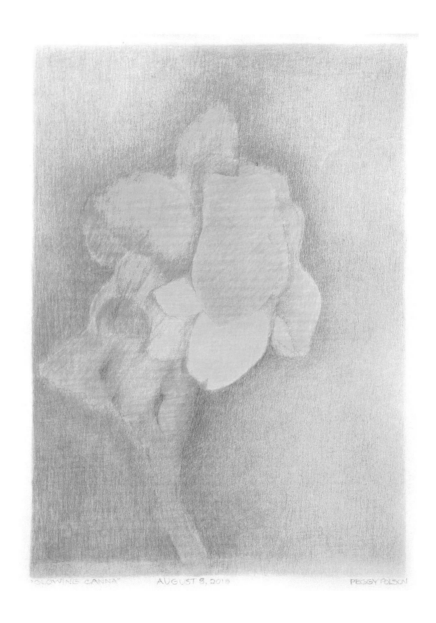

Glowing Canna, 2018, color pencil, 17.5 x 12 in.

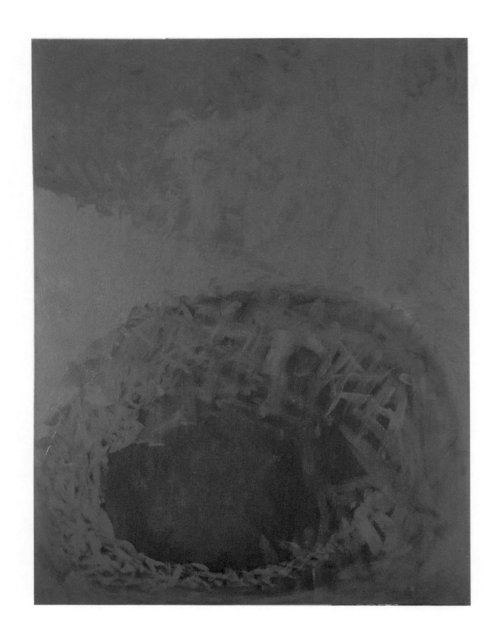

The Heart of Blue, 2019, acrylic, 48 x 36 in. *(see page 67)*

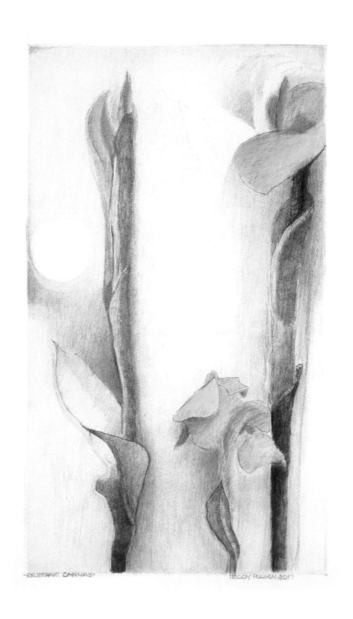

Exuberant Cannas, 2017, color pencil, 14.75 x 7.25 in. *(detail on front and back covers)*

Afterword

Peggy Polson is a true artist. Her visual language is her primary language. The words you've read here are secondary, although fascinating.

To tell her story involved a sweeping effort. Starting in 2017, I met with Peggy for brainstorming sessions, and then she began writing her memoir, planned to contain images of her artwork. Having never embraced the computer or the typewriter, Peggy built this book by handwriting on yellow-lined pads of paper, dictating to me, and making selections from aging 35 mm slides or framed pieces behind glass hanging on walls. Nothing had been digitized, and more recent work had never been photographed at all. I was present in Iowa City only every few months, and therefore we assembled this *Art Autobiography* in fits and starts. Structural themes waxed and waned and have left a rather wide-ranging style.

Reaching the cusp of a full vision of the book in March 2020 coincided with the sudden global pandemic. When I left for Oregon, we were uncertain when we could meet again, or whether we would ever meet again. Posterity will forgive my melodramatic view. A year of stagnation followed for me. Worse, I had not thoroughly collected every detail required to publish in a timely manner.

Coincident to the pandemic, Peggy moved from Oaknoll's Independent Living to Assisted Living, only to discover that under CMS (Centers of Medicare & Medicaid Services) health mandates and quarantine she experienced the feeling of unmerited imprisonment.

Peggy gave up her studio. She dispersed her artwork and even her art materials. Peggy sent me small collages of flowers cut from seed catalogs, and on the phone we talked of the psychic pain the year 2020 was wreaking.

Peggy was struck by an essay, "I, Coronavirus: Mother, Monster, Activist," by spiritual writer Bayo Akomolafe, who wrote, "Slowing down is about taking care of ghosts, hugging monsters, sharing silences, embracing the weird. Making sanctuary."

That is an entirely apt description of the isolation and sheer disruption that was the year 2020.

We cast this book aloft, still kept apart, without electronic communication, and declare it an amazing victory.

Niki Harris
Editor-Designer-Publisher
Scrivana Press
January 20, 2021 [Inauguration Day]

Coronavirus Compositions (folded cards, clockwise from top left, center last):
Symphony of Pinks; The Floral Connection; Extended Color Family; Animated Bouquet;
Red and Blue; Flower Tower; Floral Vacuum, 2020, collages, 5.5" x 4.25" each